Menorahs, Mezuzas,
and Other
Jewish Symbols

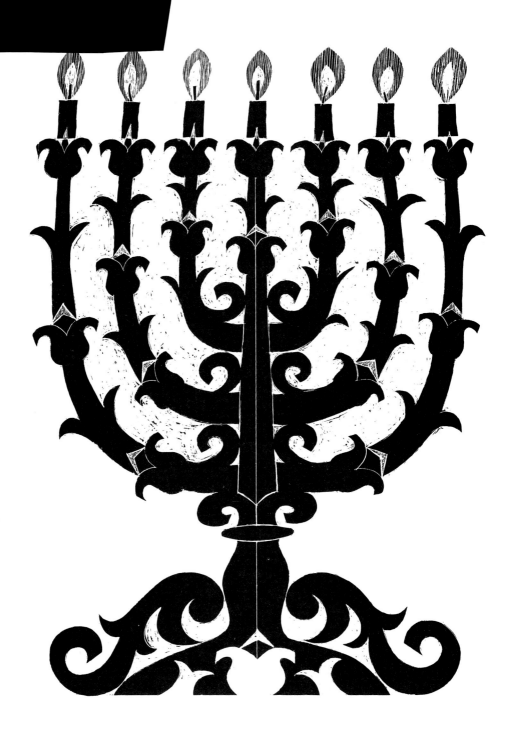

Menorahs, Mezuzas, and Other Jewish Symbols

by Miriam Chaikin

Illustrated by Erika Weihs

Clarion Books

NEW YORK

With thanks and appreciation to Rabbi Bernard M. Zlotowitz
for reading and commenting on the book in manuscript form.

Clarion Books
a Houghton Mifflin Company imprint
215 Park Avenue South, New York, NY 10003
Text copyright © 1990 by Miriam Chaikin
Illustrations copyright © 1990 by Erika Weihs

www.houghtonmifflinbooks.com

Printed in the USA.

Library of Congress Cataloging-in-Publication Data

Chaikin, Miriam.
Menorahs, mezuzas, and other Jewish symbols / by Miriam Chaikin ;
illustrated by Erika Weihs.
p. cm.
Includes bibliographical references and index.
Summary: Explains the history and significance of many Jewish
symbols, such as the Shield of David, the menorah, and the mezuza,
and discusses holiday symbols and rituals.
ISBN 0-89919-856-2 PA ISBN 0-618-37835-9
1. Jewish art and symbolism—Juvenile literature. 2. Judaism—Liturgical objects—Juvenile
literature. 3. Judaism—Customs and practices—Juvenile literature. [1. Jewish art and symbolism.
2. Judaism—Customs and practices.] I. Weihs, Erika, ill. II. Title.
BM657.2.C45 1990
296.4—dc20 89-77719

VB 15 14 13 12 11 10 9 8

For the LAMED VAV-NIKS *in my life—*
Peggy Mann Houlton, Doriane Kurz Lazare,
and my sister Payoo, Faye Chaikin Pearl.
They made my garden bloom.

M.C.

Contents

Menorahs, Mezuzas, and Other Jewish Symbols

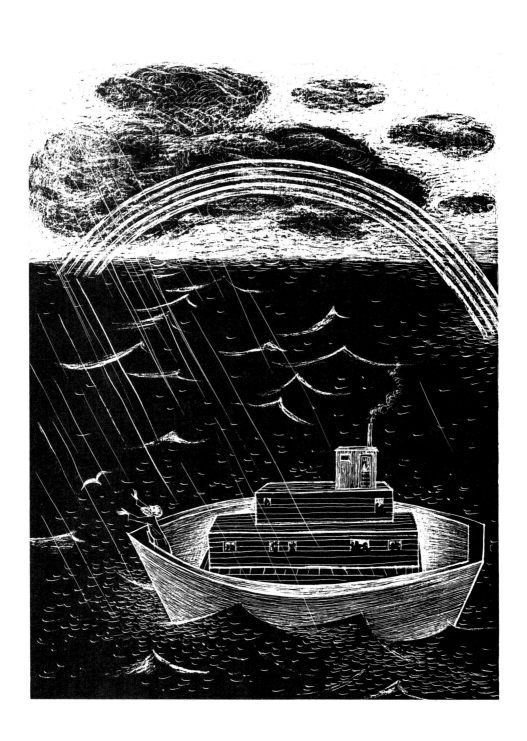

Introduction

Symbols. Signs. Reminders. These are images, acts, or ideas that stand for something else. In the Bible there are many. For Jews, the Bible embodies God's will for a just society: doing what is right, fair, and morally correct is good, doing the opposite is evil. Most Bible stories make this point. In the Noah story, God sent a flood to drown the wicked people of the earth. Righteous Noah and his family were saved in a floating ark, along with two of every kind of animal. With these pairs, God started a new world.

In ancient times, a sign or symbol represented a promise from God. After the flood, when Noah's family began to repopulate the earth, God promised Noah never again to wipe out humanity. The sign, or symbol, of that promise? The appearance of a rainbow in the sky.

The lengthy and eventful history of the Jews has produced many symbols. The story begins very long ago, in a pagan world where people believed demons and evil spirits caused illness and misfortune. Pagan religious leaders were magicians

who knew how to thwart these negative forces. They made amulets, protective or lucky charms, that kept harm away from the wearer. One type of amulet was a string or cord with seven knots. Knots tie and bind, and people believed these knots could "tie up" an evil spirit and render it harmless. Why seven? This was a magical number, perhaps because of the seeming power of the seven heavenly bodies visible in the sky. To protect himself or herself, a person wound the string around an arm or leg.

Pagans worshiped many gods. They believed one ruled heaven, another earth, and another caused fertility in plants, animals, and humans. To give a god form, these people made an idol of stone or wood to represent it, and then they worshiped the idol. If the god they worshiped did not grant their requests, they might cut down a tree and make a new idol for themselves. The Bible describes one such procedure: ". . . He takes part of it [the tree] and warms himself, he kindles a fire and bakes bread; then he makes a god and worships it, he molds an image and prostrates himself before it . . . and prays to it, saying, 'Save me, for you are my god.' "

To please a god from whom they wanted a favor, people offered the idol food and drink. They did so by placing gifts on an altar where a fire burned. Here, on the flames, they offered up their sacrifices—animals, plants, and even people. Because a firstborn son led his family when the father died, he was a favored child. As a special gift, pagans sometimes offered their firstborn sons to the gods.

Jewish history is two histories in one. It is the story of the rise of a new tribe, which begins with Abraham and Sarah, around 1800 years before the Common era, or B.C.E. Abraham and

Sarah were pagans. But they came to believe that one supreme God was the creator of heaven, the seas, the earth, and every living thing. They stopped worshiping idols and worshiped God exclusively. Through them, the knowledge of God entered the world. Thus, Jewish history is also the story of the unfolding belief in one God.

God made a pact, a contract, with Abraham and Sarah. They promised to worship only God. And God promised to protect them and make their descendants into a powerful nation, "as numerous as the stars." People in those days identified themselves by making the sign of their tribe on their flesh. Abraham circumcised himself and his male followers, signifying that they were God's tribe. This was the first symbolic act of the ancient Jews.

Many Jewish symbols reflect an event in Jewish history that took place some six hundred years later, in the time of Moses. Moses was the founder of the Israelite nation and the first, and greatest, prophet of the Jews. A prophet was a person to whom God spoke. The prophet then repeated God's words to the people or carried out God's wishes. When God spoke to Moses, the Israelite nation consisted of twelve tribes that worshiped God. They were in Egypt, where the pharaoh had made them slaves. God sent Moses to Egypt to free them, and after many tries, Moses succeeded.

The slaves that Moses freed were an uneducated, untutored mass with no set beliefs. Moses led them out into the desert wilderness. He was taking them to Canaan, the land God had promised Abraham and Sarah. The Promised Land was not far, but Moses kept the Israelites wandering for forty years, until he had molded them into a nation that swore to worship only God and to obey God's laws.

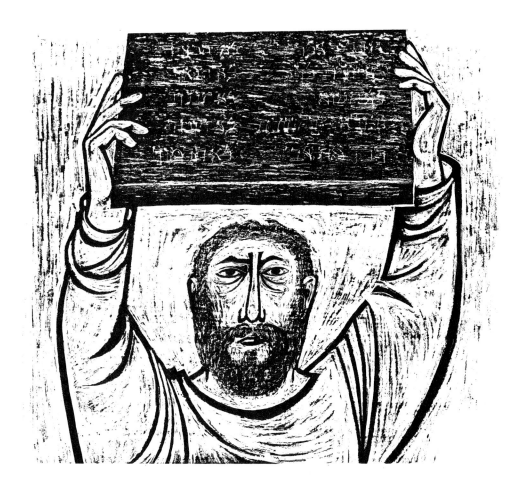

The first laws that Moses received on Mount Sinai were the Ten Commandments. Some religious scholars say God's voice dictated the laws to Moses. Others say Moses was divinely inspired on the mountaintop, and that he himself wrote the laws. The Bible says of his descent from Sinai, "And Moses turned, and went down from the mount, with the two tablets of the law in his hand; tablets that were written on both their sides, on the one side and on the other were they written."

Were these "two tablets" a single stone, with writing on the front and back, or two attached stones, with the writing on one

side? Both images have come down to us over the centuries as artistic symbols of the laws, and of the time when God's laws for a just society entered the world.

<center>*</center>

A historic figure may also be viewed as a symbol. The Reverend Martin Luther King, Jr., a leader in the struggle of American blacks for civil rights, is a symbol of nonviolent revolution. Hitler, who unleashed cruelty and barbarism in World War II, is a symbol of evil. An unspecified individual may also be a symbol. For Jews, the figure of a man bent over a book, writing, rapt in his task, is such a symbol. He represents a scribe, a religious scholar and calligrapher. He is understood to be making a copy of the first five books of the Bible—Genesis, Exodus, Leviticus, Numbers, and Deuteronomy. The five together are called the Pentateuch, or five books of Moses, or *Torah*, which in the Hebrew language means "teaching."

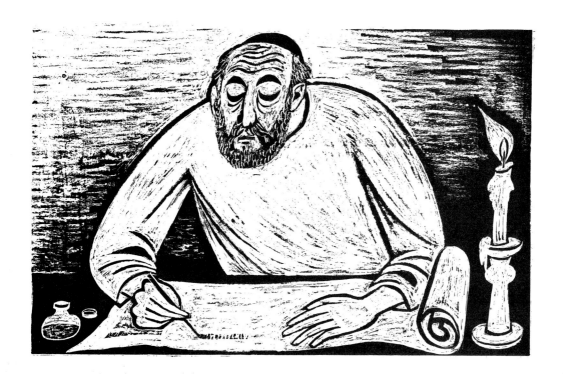

The complete Hebrew Bible consists of twenty-four books in one. The book itself is also a Jewish symbol. It contains many branches of knowledge. There are ancient legends, and stories about scoundrels and prophets, good kings and bad, loyalty and treachery. There are love stories, wise sayings, and poetry. Jews have treasured the Bible and biblical learning throughout their history and are often called "People of the Book," a name given to them by the Prophet Muhammad, the founder of the Muslim faith in the seventh century of the Common era, or C.E.

*

At the time when it was first stated, the idea of one God was difficult for people to grasp. Understanding and belief unfolded only gradually, over the centuries. Many Jewish symbols reflect this process.

Superstition is a potent force. Even when the ancient Jewish religion was well established, people still used amulets to protect themselves against misfortune. From the time of Moses onward, Jewish sages—religious leaders and scholars—tried to wean people away from such practices. Their message was: "Give up your amulets and place your faith in God." But old habits die hard, and people were reluctant to part with their protective aids. So the sages, when they could not uproot a superstitious practice, changed it by giving it religious meaning.

The Jewish symbol of *tefillin* is a possible example of how the ancient practice of winding became something else. The singular of *tefillin* is *tefilla,* which in Hebrew means "prayer." Tefillin are two little, square, leather boxes attached to straps. Each box contains four selections from the Bible. Two are from the Book of Exodus and two from the Book of Deuteronomy.

The two from Exodus show how Moses shaped the thinking

of the nation he established. He commanded the people never to forget that they were slaves in Egypt, and to impress this fact upon their children as well. The command served two purposes. One was to keep alive the memory of their experience in Egypt.

God sent ten plagues to punish the Egyptian pharaoh for refusing to free the Israelite slaves. The Israelites witnessed the plagues and saw the wonders God had worked for them. But human beings have short memories. They might, with time, begin to think that they became free because of their own efforts. The two selections from Exodus serve to remind Jews that God worked wonders to free them, and that they owe their freedom to God.

The second purpose of the command was to build the Israelite character. By remembering the painful days of their slavery, Israelites would develop compassion for others.

Moses did not rely only on his oral command. He told the Israelites to make a "sign" on their hand and another "between their eyes" as reminders that they belonged to God's tribe. And he gave the Israelites one more decree: to dedicate their firstborn sons to the priesthood. This requirement served two purposes. Besides laying down religious principles, Moses also established a system of worship based on God's command, "Let them [the Israelites] make me a sanctuary, that I may dwell among them." The Israelites built a special tent for God, which they called the Tabernacle. There God was served by Tabernacle priests. One purpose of dedicating eldest sons to the priesthood was to thank God for sparing the Israelite firstborn. The tenth plague had killed all the Egyptian firstborn, including the pharaoh's own son. The Israelite firstborn were exempted.

The second purpose was to teach the Israelites the will of

God. Moses told them that child sacrifice was an abomination, that it was hateful to God. He outlawed the practice among them. The command to dedicate firstborn sons to the priesthood was also a means of ending that practice.

The remaining two selections in the tefillin are from the Book of Deuteronomy. In the first selection, Moses articulates the one, central belief of the Jewish religion:

> Hear, O Israel: The Lord our God, the Lord is One. And you shall love the Lord your God with all your heart, with all your soul, and with all your might. And these words, which I command you this day, shall be upon your hearts; and you shall teach them to your children, and talk of them in your home and when you walk about outside, and when you lie down, and when you rise up. And you shall bind them for a sign upon your hand, and they shall be for frontlets between your eyes. And you shall write them upon the doorposts of your house and of your gates.

The command became Jewish law. Exactly what the signs and frontlets were to be was not clear. This was left to Jewish sages to determine. According to one legend, King David wore a sign on his hand, but what that was is not known. A thousand years later, however, the "signs" already had the form they have today. In the first centuries B.C.E. and C.E., pious Jews walked around the streets of Jerusalem wearing tefillin. Greeks, observing the boxes, believed them to be amulets and called them *phylacteries*—Greek for "amulet" or "protection." The word has passed into the English language.

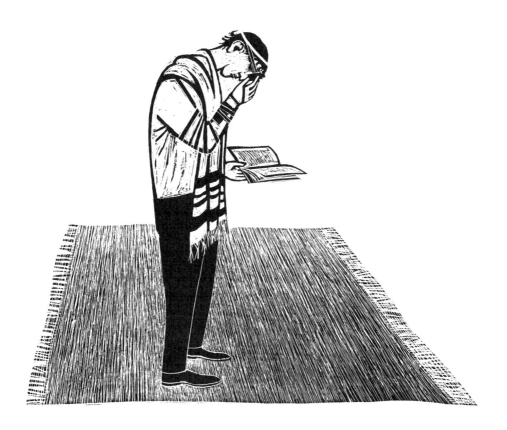

Every day, except for Saturdays and holidays, a religious Jewish man wears tefillin during his morning prayers. He straps one box, the frontlets, to his forehead, so that it rests "between his eyes." The other he fixes to his forearm by winding the strap around his arm seven times. Is the number seven left over from ancient superstition? And were the knots? And the binding and tying? Probably. But the old associations have disappeared.

The sages had assigned a new meaning to the number seven. It became a symbol of the Creation story in the Bible, in which God created the world in six days and rested on the seventh.

In the winding, no harmful spirit is being bound. As the man winds the strap around his arm and fingers, he recites the words of God spoken by the Prophet Hosea, "And I will marry you to Me forever. Yes, I will marry you to Me in righteousness,

and in justice, and in lovingkindness, and in compassion." The winding is symbolic of a wedding ceremony.

Usually, only men wear tefillin. Some scholars say women in earlier times may have done so too. They mention Michal—the daughter of Saul, the first king of Israel—who later married King David. They mention also the daughters of Rashi, the leading Jewish Bible scholar of the eleventh century, who lived in France. Jewish customs are flexible and often change with the times. Keeping this in mind, some devout women today have begun to wear phylacteries. They, too, wish to have the experience of "marrying themselves to God" when they pray.

<div align="center">*</div>

The ancient belief in stars is another example of how religious meaning triumphed over superstition. In the first centuries B.C.E. and C.E., many Jews, and even their religious leaders, still worshiped stars. They looked upon stars as living entities, as angels, and believed stars ruled their lives. They studied the nighttime sky hoping to see a *mazal* (a star or constellation that they considered lucky). The sages taught that while stars may rule men, God rules the stars. If a star indicated bad luck, a person could escape the decree by doing good deeds. Today, the Hebrew word *mazal* has no connection to stars but means, simply, "luck."

<div align="center">*</div>

For Jews, time itself is a symbol. The Jewish day starts at sunset, with the coming of darkness. According to the Creation story, there was a void, a nothingness, before the world was created. Then God made the light and the dark, and "there was evening and there was morning, one day." Evening is mentioned first. Therefore, ancient sages who gave form to the Jewish religion said a day started in the evening.

The seventh day, the Sabbath, is another time symbol. For Jews, this is Saturday. Before the teachings of the Bible were committed to writing, the Sabbath went without a name. It was called, simply, "the seventh day." Around 590 B.C.E., the king of Babylonia, today Iraq, conquered Jerusalem and exiled the captive Jews to his capital, Babylon.

In Babylonia also, the seventh day was a day of rest, but for a different reason. People stayed home because it was a bad-luck day. To keep the king safe from harm, astrologers advised him not to go near fire, ride in a chariot, or even change his clothes. On that day, doctors did not treat the sick. The day of the full moon, called *shabbatum*, was also a day of rest. The Babylonians believed that demons and evil spirits roamed the streets on these bad-luck days, and everyone, including the king, stayed home. In time, a later Babylonian king lost his kingdom, despite the care taken to protect him. When the Jews went back to Jerusalem, they began to call their seventh day *Shabbat*.

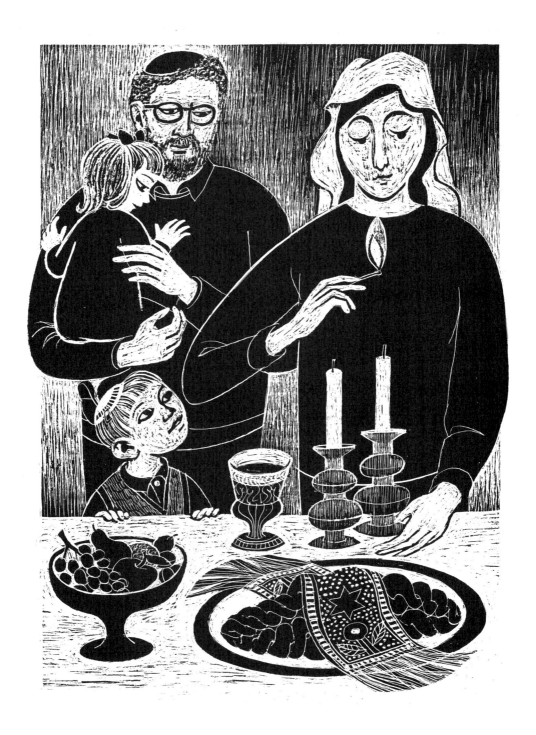

1. The Sabbath as "Queen" and Symbols of the Sabbath

The Sabbath as "Queen"

Some Jewish symbols are concepts, or ideas, which have their roots in the Bible. Other symbols may be actual physical objects that represent things unseen. The Sabbath offers examples of both.

> Six days you shall labor, and do all your work, but the seventh day is a sabbath of the Lord, and that day you shall not work, neither you, nor your son or daughter, nor any of your servants, nor your cattle, nor the stranger that is within your gates.
>
> *The Fourth Commandment*

As the words of the commandment indicate, the Sabbath was to be a day of rest, not only for people but for animals as well. This was a revolutionary thought at the time. Israelites, and all other peoples, worked daily, and all day long, to feed and clothe themselves. To stop work for one day was a startling idea, and this helped to make the day special. But rest alone

was not enough, for it could lead to idleness. Moses told the Israelites to keep the day holy because it was a symbol, a sign, of Creation, and because God had blessed it.

How did Jews keep the day holy? Not by sadness but by rejoicing and celebrating. The features of the celebration evolved over the centuries. The Prophet Isaiah said to the people of his day, "Call the sabbath a delight." Ezra, a scholar and teacher, defined delight when he told people how to celebrate a festival: "Go eat rich dainties and drink sweet drinks, and send portions to those who have nothing ready, for this day is holy to the Lord."

People expressed their delight in the Sabbath by feasting and drinking wine. Some, however, carried the idea too far. To balance earthly pleasures with thoughts of God, the sages made certain rulings. They said the dining table symbolizes a holy altar, and that people seated there should act with dignity. They said God's spirit visits only those homes where Torah teachings are discussed at the table. They also introduced blessings, words of thanks, to be said to remind people that the food and drink they were about to enjoy came from the earth and were a gift from God.

The rabbis—scholars and teachers—also found delight in food and wine, but even more so in spiritual thoughts. The idea of God filled them with wonder. They used the Sabbath rest to reflect on the perfect world God had created—order in the heavens and in the seas, the great variety of life on earth. They thought about God completing the work of creation and resting on the Sabbath. That idea led them to believe that when they rested on the same day, they shared the Sabbath rest with God.

Around the third century C.E., the Jewish sages carried the

idea further and created a new symbolic concept: The Sabbath was a living presence, a beloved, feminine presence whose coming they eagerly awaited. They called the Sabbath "her," and spoke of her as "bride" and "queen." One rabbi added still another idea. He said a person receives a second soul on the Sabbath, a Sabbath soul.

In the sixteenth century C.E., the poet-rabbis of the town of Safed in Palestine created a ceremony based on these ideas. The Sabbath begins on Friday, at nightfall. The rabbis bathed and groomed themselves on Friday afternoon, delighting even in the preparations. Then they dressed in robes of white—the symbolic color of purity. While it was still light, they and the children of Safed marched up and down the hills, singing a song of welcome to the Sabbath. The song begins, *L'cha Dodi, likrat kallah, pnei shabbat, nikabala* (Let us go, dear friends, to meet the bride, the Sabbath presence, let us greet her.)

Today, this outdoor ceremony is a thing of the past. But during Friday night services in many synagogues, it is recalled with a symbolic gesture. Before services begin, people stand, turn to face the door, and welcome the Sabbath by singing the *L'cha Dodi* song. Yemenite Jews do this in their own way. They do not face the door, but standing in place and singing, they bounce on their toes in a symbolic dance.

Symbols of the Sabbath

Three main symbols suggest the Friday night celebration, the start of the Sabbath. Jews have been lighting candles to welcome the Sabbath since the second century B.C.E. Light is seen as a blessing. The flames give light, God's first creation, and are a symbol of life.

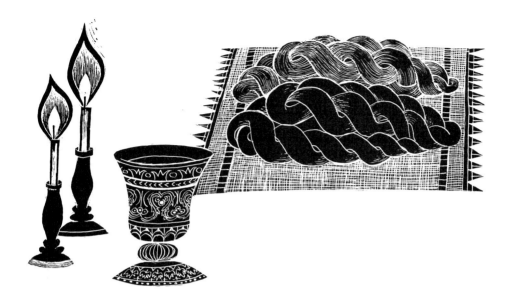

Two loaves of the finest white bread (*challah*) are another symbol. They stand for the blessings of food that the earth provides. Why are there two loaves? When the Israelites in the wilderness complained about hunger, God sent them manna, a sweet, white substance, to eat. Nature scientists suggest this was something released by trees, like sap, or by insects that lived in the trees. Each day enough manna fell to feed everyone, and each day the Israelites collected their daily food. A double portion fell on Friday, so they would not have to work on the Sabbath. The two loaves are a symbol of the double portion.

The third symbol is a wine goblet. The grape, the fruit of the vine, is a double blessing. It is eaten as fruit and may also be pressed into wine. Wine is a symbol of goodness and gladness.

Before eating the Sabbath meal, the family stands around the table. The head of the house takes the goblet in hand and says: *Blessed are You, O Lord our God, King of the universe, who*

creates the fruit of the vine. The two challahs are covered during the wine blessing. The cover is removed and this is said: *Blessed are You, O Lord our God, King of the universe, who brings forth bread from the earth.*

The sages used every occasion to make children sensitive to the feelings of others. When children ask why the challahs are covered, they are told: "So the bread won't be jealous that the wine was blessed first." After the meal, those around the table sing songs of praise to God in gratitude for the good things of the earth.

Saturday night, the end of the Sabbath, has its own symbols. They are used in the *havdallah*—the separation (from the Sabbath)—ceremony. One is the havdallah candle, a special

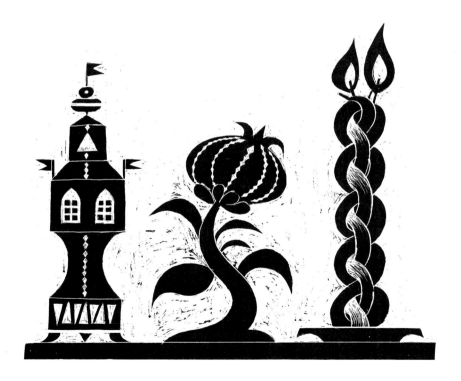

braided candle with two wicks. One wick stands for the regular days of the week, the other for the holiness and joy of the Sabbath.

Another symbol is a spice box. It may be an actual, simple box, a beautifully carved flower that opens, or an elaborate silver tower. The tower is a popular shape because in the Middle Ages, in Europe, precious spices were kept in towers. The box contains cloves and/or other fragrant spices. At the end of the havdallah ceremony, it is passed around for everyone to sniff and take delight in the blessing of spices.

There is a saying: Orthodox Jews hate to see the Sabbath end because they do not want to give up its delights. Spices, like smelling salts, are used to revive people who feel faint. Saddened by the idea that the Sabbath is leaving, Orthodox Jews smell the spices to keep from fainting. There is another saying: Orthodox Jews smell the spices for the sake of the Sabbath soul, hoping it will remember the pleasantness of the Sabbath and return again the following week.

Jews have suffered many upheavals and persecutions in their long history. In view of this, many people wonder how it is that the ancient Jews are still here, that they haven't been wiped out. A modern Jewish philosopher who called himself *Ahad Ha'am* (One of the People) suggested one reason why this might be so: More than the Jews have kept the Sabbath, the Sabbath has kept the Jews.

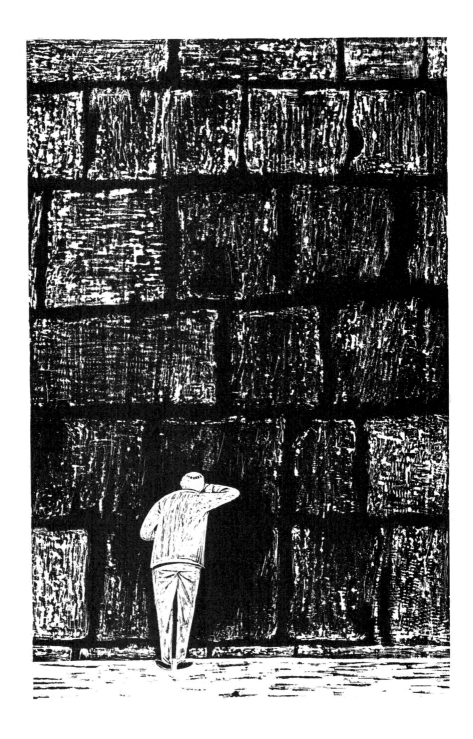

2. Symbolic Ideas

The Shechinah (the Divine Presence)

In the desert wilderness, God commanded Moses, "Let them [the Israelites] make me a sanctuary, that I may dwell among them." God also said, "I will walk among you and will be your God, and you shall be my people." Thus, when the sanctuary, or Tabernacle, was built, the Israelites believed God was in their midst. They believed a Holy Spirit, an aspect of God, visited the earth and dwelt among them. This aspect of God was the *Shechinah.* The name comes from the Hebrew word *shachan,* which means "to dwell." In the Bible, God is referred to in the masculine, as He, Lord, King, Father, Master. Like the Sabbath, the Shechinah was believed to be a living, feminine presence. The Shechinah, the aspect of God that visits the earth, is referred to as She and is also called the Divine Presence.

The Western (Wailing) Wall, Symbol of Hope

The Shechinah figures in the story of another symbol, the Western, or Wailing, Wall in Jerusalem. Around 955 B.C.E., King

Solomon built a Temple in Jerusalem to replace the desert Tabernacle. Surrounding the Temple was a stone wall. When the Babylonian king devastated Jerusalem in 586 B.C.E., he also destroyed the Temple. Only a part of the Western Wall was left standing. Some fifty years later, when the Jews returned to Jerusalem, they rebuilt the Temple.

In the last years of the first century B.C.E., King Herod renewed and expanded the Temple, adding great staircases, porches, and plazas, making it into one of the most beautiful buildings in the world. In 70 C.E., Jerusalem and the Temple were again destroyed, this time by the Romans. But once more, the Western Wall remained intact.

Since this wall remained standing after two great upheavals, Jews viewed its survival as a sign. They believed that the Western Wall was a holy place from which the Divine Presence (Shechinah) never departed. The wall gave the Jews hope, although the Romans forbade them to live in Jerusalem, and the name of their land was changed from Judea to Palestine. Jews saw the wall as a sign that God would one day return them to their land and make them an independent, sovereign nation again. Wherever they lived, they turned to Jerusalem to pray, ending their prayers with the words: "Next year in Jerusalem."

Slowly, centuries later, Jews made their way back to Jerusalem. In the 1880s, fleeing life-threatening conditions in Europe, Jews began to arrive in greater numbers. After waging several bloody wars for independence, they finally saw the words of the ancient Prophet Ezekiel come true: "I will gather you from the peoples and assemble you out of the countries where you have been scattered and I will give you the land of Israel." On May 14, 1948, the United Nations reestablished Israel as a self-governing nation.

The Messiah

A *messiah* is someone who has been singled out by God, an anointed one. The idea has its roots in the story of King David. The kingdom David established in Jerusalem around 1000 B.C.E. lasted for almost five hundred years.

When the Babylonian king destroyed Jerusalem and took the Jewish king and all the royal family captive, the Israelites were greatly disturbed. How could such a thing happen? Hadn't God made a pact with David? The Prophet Nathan spoke with the voice of God, as did all prophets. And Nathan had told David his kingdom would last forever.

The Israelites found comfort in the words of Jeremiah, a prophet of their own time. Jeremiah said David's kingdom had not been ended, only interrupted. Of God's pact he said poetically: "If you can break My pact with the day, and My pact with the night, so that day does not come nor the night also, then My pact with David may also be broken."

Babylon later fell, and the Israelites returned to Jerusalem. David's descendants reigned again, but not for long. Perplexed, the Israelites searched the Bible for explanations and began to reinterpret God's promise to David.

Isaiah, an earlier prophet, had said a time would come when people would "beat their swords into plows, and their spears into pruning hooks, when no nation shall raise a sword against another nation, or think in terms of war." Jeremiah, speaking for God, said: "I will cause a righteous descendant of David to appear, and he will bring justice and righteousness to the land. In those days will Judah [Israel] be saved and dwell in safety in Jerusalem."

From these prophecies, the Israelites concluded that David's

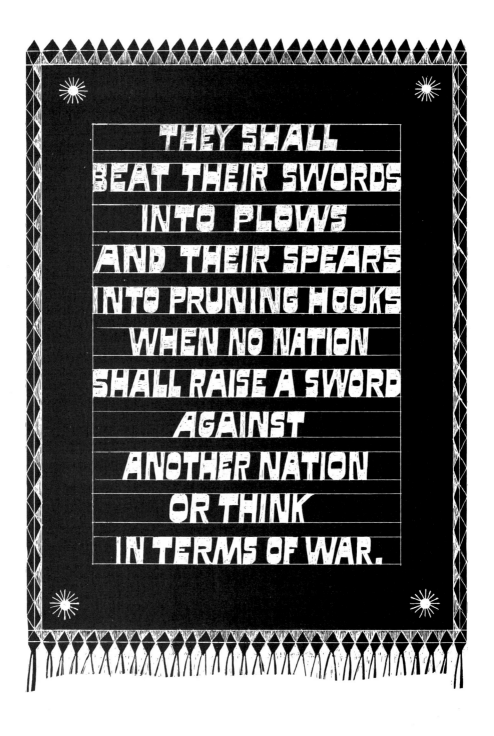

THEY SHALL
BEAT THEIR SWORDS
INTO PLOWS
AND THEIR SPEARS
INTO PRUNING HOOKS
WHEN NO NATION
SHALL RAISE A SWORD
AGAINST
ANOTHER NATION
OR THINK
IN TERMS OF WAR.

24

kingdom would indeed last forever, but not as an earthly kingdom, which would be only a place of greed, war, and bloodshed. They saw a heavenly kingdom arising in the future, a kingdom free of war, hunger, and jealousy. Peace and prosperity would be enjoyed by all. Reigning over the heavenly place would be David's descendant, the Messiah, continuing David's rule.

For centuries, Jews have been praying for a messiah to come and usher in such a heavenly kingdom. When Israel was declared a state in 1948, most Jews were content to see an earthly Jewish nation rise again. A religious sect living in Jerusalem, the *Natorei Karta* (Aramaic for "Guardians of the City"), opposed and remains opposed to the State of Israel. Israel is an earthly, democratic state. The sect is waiting for the kingdom the Messiah will rule.

Angels as Symbols of Good

The first mention of angels in the Bible is in the Adam and Eve story. Adam and Eve disobeyed God and were punished with banishment from the Garden of Eden. In the Garden is the tree of eternal life, and to eat of its fruit is forbidden. To keep anyone from trying, God placed *cherubim* at the entrance to the Garden. They are formless spirits who bar the way to the tree of life with spinning swords of flame.

Later in the Bible, when Jewish history begins, three angels appear in the story of Abraham and Sarah. They are God's messengers, angels in human form, and they came to earth to carry out God's wishes. The Hebrew word *malach* means both "messenger" and "angel."

The idea of angels as guardians appears again in the King

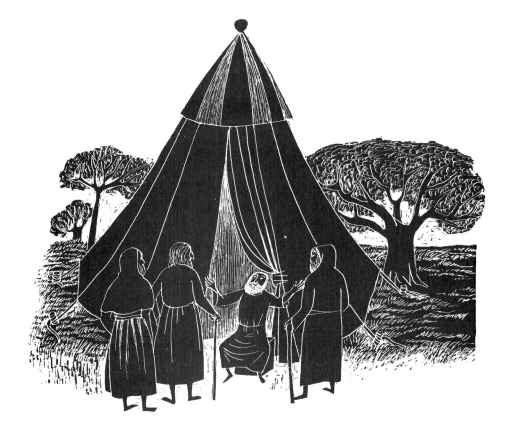

Solomon story. Here, the cherubim were represented by figures with human heads, animal bodies, and wings, and their likenesses decorated the Temple walls and doors. Inside the Temple, there were two large, wooden cherubim covered with gold leaf. They guarded the ark that held the Ten Commandments. Their great, outstretched wings filled the room, and the space between their wings was believed to be the "throne of God," the place where God's spirit dwelt on earth.

Yet other angels were described by the Prophet Isaiah. In a vision of heaven, Isaiah saw God seated on a throne, surrounded by countless *seraphim*. They are singing angels with six wings: two cover their faces, two their feet, and with two they fly about.

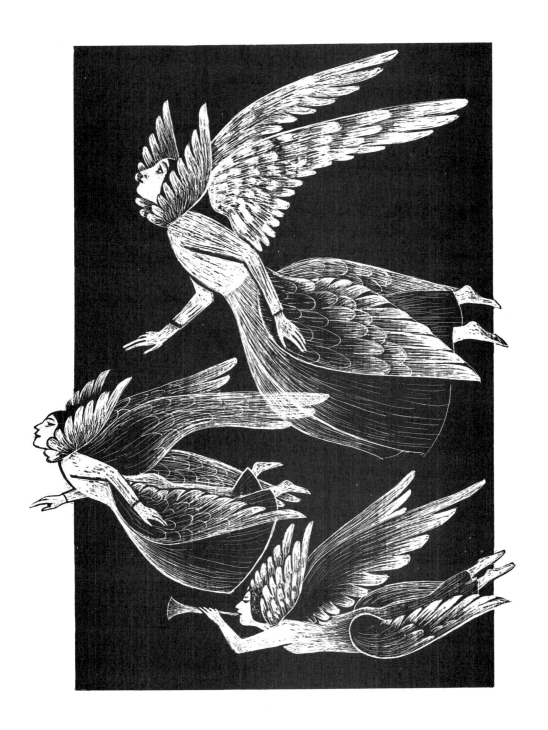

The biblical story of Job also speaks of singing angels. The creation of the world is poetically described as a time "when the morning stars [believed to be angels] sang together, and all the children of God [also angels] shouted for joy." The Job story also speaks of a heavenly court of angels. Some of these angels are God's messengers, who roam the earth and report to God on the doings in the world. One of them is called Satan.

Based on this assortment of angels, the ancient Jewish sages created a large body of literature, including songs and poems, about angels. They populated heaven with a vast array of imagined angels, each with different duties. In order to answer people's questions about God, and about life in heaven and on earth, the sages told little stories using angels.

Where did angels come from? God made them.

Who are angels? They are celestial beings, less holy than God but holier then humans. Humans, however, have an advantage over angels. They are aware of the greatness of God. Angels do not have this awareness. They will gain it only after the Messiah comes.

Is God lonely in heaven? No, the angels keep God company and sing God's praises all day long.

Who was God talking to when God created humans and said, "Let us make mankind in our image?" God was talking to the angels.

How far away is God? God is very far, seven heavens, away, but still within reach because an archangel, an intermediary, is in charge of each heaven. Some names change, but the four archangels mentioned most often are Michael ("Who Is Like God"), Gabriel ("Man of God"), Rafael ("God Has Healed"), and Uriel ("God Is My Light").

How does God manage the universe? God created countless

helper angels who rule the winds, the coming of day and night, and all of nature. They form a spiritual ladder to heaven, linking Jews to God, earth to sky. Besides these, there are personal angels. Everyone receives a guardian angel at birth. Each of the seventy nations of the world (the ancient sages believed there were seventy nations) has its own personal angel. In fact, according to one sage, "There's not a stalk on earth that has not its angel in heaven."

How does God hear our prayers? Messenger-angels who roam the earth return to heaven carrying the prayers of the righteous. Thus, though God is far away, all these angels connect to form a spiritual link to heaven. They are a way to reach God.

The idea of angels took hold of the public imagination. A time came when people began to worship angels and to appeal to them for help, rather than to God. The sages prohibited the practice and began to speak less about angels. In due course, Jews stopped worshiping angels, but they never wholly gave them up. Angels continue to be seen as God's helpers, a force for good, and a way of reaching God.

Demons as Punishment and Symbols of Evil

The first wicked act in the Bible occurs in the Adam and Eve story. God allows Adam and Eve to eat the fruit of any tree in the Garden of Eden, except for the fruit of the tree of knowledge. The Serpent in the Garden tempts, even dares, them to eat the forbidden fruit, and they do. The three have disobeyed God and are punished. The punishment of Adam and Eve is less severe, because they were innocent, trusting, and easily misled. They had intended no evil. The Serpent, however, was

smart and knew what he was doing. He committed an evil act when he tempted them to do wrong. He, therefore, receives the worst punishment. He is condemned to crawl on his belly for all time.

In the Job story, Satan, the roaming angel, returns to heaven with a report about Job. Satan casts doubt on Job's faithfulness to God. A person faithful to God not only worshiped God but also lived by God's ethical laws. Satan says Job was not steadfast and could be led into wickedness. God doesn't believe the accusation but allows Satan to go back to earth to prove his point. (Satan does not succeed.)

Ancient Israelites accepted the ideas that God punished the wicked, and that spirits that brought sickness, misfortune, and calamity were God's agents of punishment. But the Israelites faced a dilemma. What about good people? Why were righteous people punished? Their sages offered answers. Some said God was too great for people to understand. Just as no one could understand how the earth produces food to eat, so no one could understand other acts of God. Other sages said, yes, God sends harmful spirits to punish the wicked, but there are also independent demons in the world who do evil acts on their own.

Rashi, the great Bible scholar in eleventh-century France, agreed. He used the story of Noah and the ark to make his point. According to the Bible, Noah took "every living thing, two of every sort," into the ark. And Rashi said, "Every living thing meant also demons." The idea of demons with names, backgrounds, and special skills existed long before Rashi. As angels helped answer questions about goodness and protection, demons helped answer questions about the mystery of sickness and calamity.

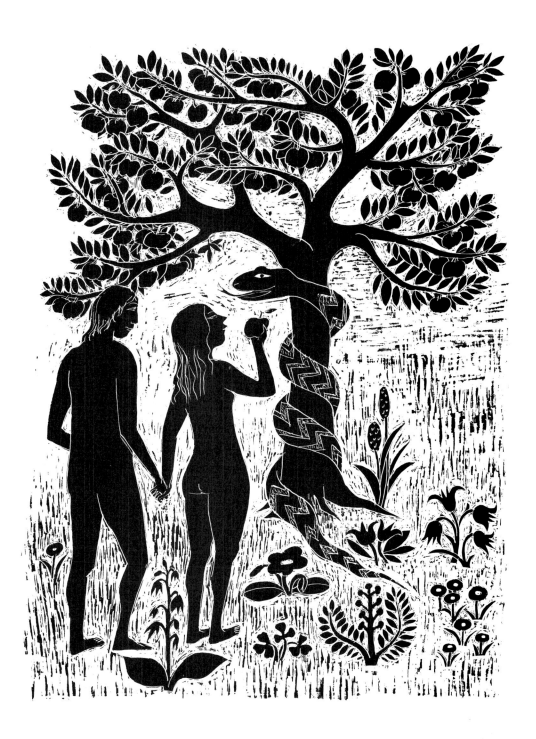

They were believed to be invisible spirits who lived in the air. They could take on human shapes and look like people, but their wings and goat's feet gave them away. Demons lived in barren places and practiced their evil at night.

Where did they come from? They were children of bad angels and of the spirits of the wicked dead. Ashmedai was their king; Lilit, the night demon, was their queen. Satan, later called the Devil by Christians, ruled them all. The "evil eye" was an independent demon. A person could, without knowing it, possess an "evil eye." The glance of such a person was believed to bring misfortune, as was that of a jealous person.

Amulets for combating evil never lost their popularity. In the second century C.E., the word *abracadabra* was thought to be magical. It was chanted to ward off fever or inflammation, or it was written repeatedly to form a triangle and worn as a protection against disease.

Since infants were especially vulnerable, mothers took extra precautions to protect them from evil. Lilit, the night demon, was greatly feared as the "infant killer." She could be warded off with an amulet inscribed with the names of three angels

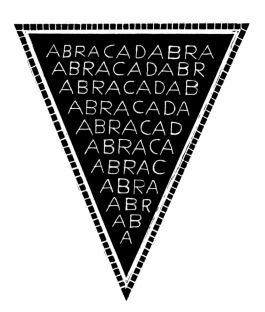

who guard children: *Senoi, Sansenoi,* and *Semangelof.* The color red was also an amulet that could scare away a demon. To protect babies from the "evil eye," mothers put a red ribbon on the crib. The act of spitting also served as an amulet, and so did the number three. Mothers spat three times to cancel an evil intention against their babies.

Maimonides, a philosopher and physician, was the leading Jewish scholar of the twelfth century. He disagreed with Rashi: he said there were no demons, and that the only defense against evil was to pray and live an ethical life. Over the centuries, his view came to prevail. Most sages agree with him. Even so, they are cautious. If someone believes an amulet can help, the sages say there is no harm in using one.

People today, Jews and non-Jews, also tend to be cautious. They may say they don't believe in demons, but they take no chances. Some still call on the number seven for good luck or avoid the number thirteen in an effort to sidestep trouble. (Do they know that thirteen came to mean trouble because a fire broke out in the harem of an ancient Babylonian king, trapping and killing his thirteen wives?) They may rub a rabbit's foot to bring luck, or hang a horseshoe over a farmhouse door—some say they do this to bring rain, others believe it's to keep away evil spirits.

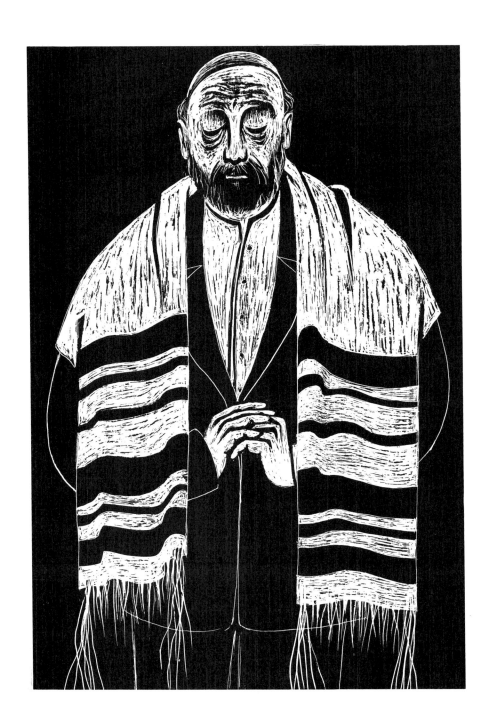

3. Symbolic Garments and Dress

Tallit

The *tallit* is a long, striped prayer shawl with four corners. There are fringes at each corner, each fringe consisting of eight threads. Originally, seven were white, and, according to Maimonides, one was blue. The fringes are worn in obedience to a biblical command: "And the Lord said to Moses, 'Speak to the Israelites and instruct them to make for themselves throughout their generations fringes [*tzitzit*] in the corners of their garments, and to attach to the fringe at each corner a thread of blue.'" The reason for the choice of blue is lost. But sages, filling in the gap, suggested a reason of their own: Blue is used because the color resembles the sea, the sea resembles the sky, and the sky is a reflection of the sapphire throne of God.

A fringe is made by winding threads and making knots. Did this custom have its origin in pagan times? Perhaps so. But the fringes received a new meaning, as the command makes clear: "Let the fringe be a sign for you to look at and recall all the commandments of the Lord and observe them, so that you do not follow the temptations of your heart and eyes, and so that

you may remember and do all my commandments, and be holy."

Tzitzit ("fringes") comes from the Hebrew word *tzutz*, which means "to gaze." The fringes were a reminder, an aid to contemplation. The wearer, seeing them, was reminded of his vows. Gazing at the fringes helped him focus his attention on the meaning of the words. The tzitzit were also a sign to others. In pagan times, all men wore the same outer garment, a large, four-cornered cloak with a hole for the head. Adding fringes to the four corners of the garment set the wearer apart. Fringes identified him as an Israelite, a worshiper of God. In later centuries, many Jews lived outside their own land, in places where such a cloak was not worn. Gradually, the cloak gave way to the tallit, the blue-and-white-striped rectangular prayer shawl worn today.

The tallit is a symbol of coming of age for a Jewish boy. At thirteen, a boy receives his first prayer shawl. He becomes a *bar mitzvah* ("a son of the commandments"), and is now considered old enough to fulfill the obligations of an adult Jew. The occasion is celebrated in the synagogue, where the boy reads aloud from the Book of Prophets and leads the worshipers in prayer. In liberal synagogues, girls undergo a similar ceremony, usually without, but sometimes with, a tallit. At age twelve or thirteen, a girl becomes a *bat mitzvah* ("a daughter of the commandments"). She, too, is called to the stage to read aloud from the Book of Prophets.

An Orthodox Jewish man puts a tallit around his shoulders before he begins his morning prayers. He looks at a fringe, as the Bible instructs him to do, and brings it to his lips for a kiss. Then he says, *Blessed are You, O Lord our God, King of the*

universe, who has sanctified us with commandments, and has commanded us to wrap ourselves in tzitzit, and begins to pray. A tallit is very large. The man may wrap it around himself, enclosing himself inside with his thoughts of God. Many Orthodox men ask to be buried in their tallit.

Over the centuries, only men have worn the prayer shawl, and only men have been rabbis. But, as times change, Jewish customs often change with them. Today, in a liberal synagogue, the rabbi may be a woman, and she may wear a tallit. Other women have also begun to wear a tallit during worship.

Arba Kanfot (Four Corners)

The ancient four-cornered cloak did not disappear entirely. Pious men did not want to wear fringes only at prayer time. They wanted to see them at all times, as the Bible commanded. They began to wear a small version of the ancient four-cornered cloak as an undergarment. The *arba kanfot* (four corners), as the smaller garment is called, fits over the head and is worn under the shirt. The fringes hang over the pants so the wearer may see them. They are a symbol of a religious Jew.

Skullcap

A common symbol of relatively recent origin is the skullcap (*kipa* in Hebrew). The little hat, a token head covering, is perhaps better known by its Yiddish name, *yarmulka*.

In ancient times, only Temple priests wore a head covering. When the Temple was destroyed by the Romans in 70 C.E., synagogues, already in existence for hundreds of years, became

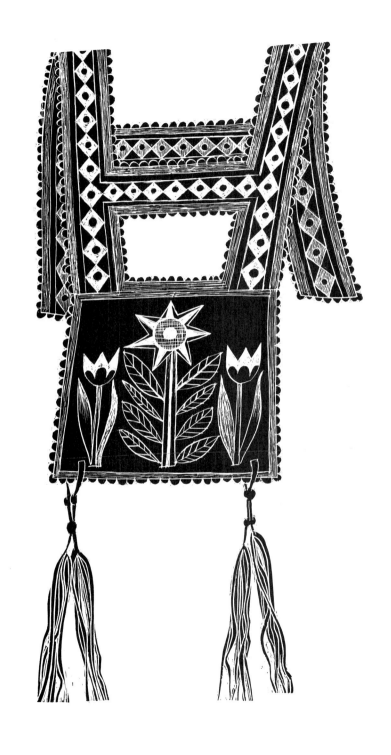

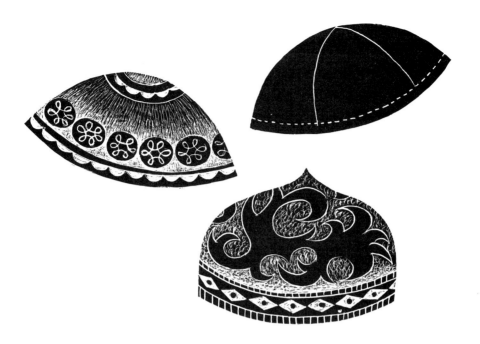

the centers of worship. Priests, who had conducted ceremonial worship and maintained the Temple, were replaced by rabbis, who were scholars and teachers. Some rabbis felt the need to express an awareness of God throughout the day, so they began to wear a sign, a hat, as a mark of respect to God.

The words of the Prophet Isaiah contributed to the idea. The angels that Isaiah saw in his vision of heaven were flying about and singing, "Holy, holy, holy is the Lord! The whole world is full of God's glory." If the whole world was full of God's glory, then God was everywhere, not only in a house of worship or study. This thought was reflected by Rabbi Huna, a Palestinian rabbi of the fourth century C.E. He would not take even a few steps bareheaded, because "the Shechinah [God's presence on earth] is above my head."

The idea spread slowly. Some rabbis covered their heads at all times. Jewish scholars did so when they prayed and while they were engaged in religious studies. In the 1500s, the custom of wearing a hat as a sign became universal among Jews. Joseph Caro, the leading Jewish scholar of the day, decreed that men should not go bareheaded.

Ever since, Orthodox Jewish men and boys have worn a skullcap at all times. Why don't Orthodox women and girls? This explanation is sometimes given by Orthodox men: Men need a hat to remind them that God is above them, but women are aware of the presence of God at all times and don't need a reminder.

Conservative Jewish men wear a skullcap for prayers, for home celebrations, and sometimes also in the street. Some liberal Jewish men wear a head covering only when they pray, if then. They follow the custom of the Jews of biblical times, who went bareheaded. In recent years, some liberal and Conservative women have begun to wear a hat for prayer.

Side Curls and Uncut Beards

The men of a certain sect are walking symbols of the Jewish religion. They wear a head covering at all times as well as tzitzit (fringes), and they wear dark clothing of certain fabrics. They let their sidelocks grow into long curls. These men do not trim their beards because they take literally the biblical command "You shall not round off the side growth on your heads, nor mar the corners of your beard." These men are *Hasidim*, which means "pious ones." They, their wives, and their children obey

all Jewish religious laws to the letter. Like the Christian Amish who preserve old customs, Hasidim shun television, movies, and other modern entertainments. They concentrate on sacred studies and thoughts of God.

The Hasidic movement arose some two hundred years ago, in eastern Europe, where millions of Jews once lived. Most were poor and wretched, and many had forgotten how to read Hebrew. Illiterate people could not pray in the synagogue, because the prayer books were printed in Hebrew, or study the Bible.

For comfort, they turned to a *baal shem* (master, or knower, of the name). "Name" referred to the many names of God, among which are *Yahweh, El, Adonai, Elohim*, Helper, Savior, Rock, and King of Kings. A baal shem was a healer, miracle worker, and amulet writer. He knew which name of God, or which angel, to call upon for relief. Some baal shem were frauds. Others were pious and sincere. One reached great fame. He was the *Baal Shem Tov,* the Good Master of the Name.

In the 1700s, the Baal Shem Tov whose real name was Rabbi Israel ben Eliezer founded the Hasidic movement in Europe. He had a spiritual experience that brought him close to God. He went from village to village preaching a new message to people whose lives were bleak: "Rejoice, and make God happy."

He preached by telling stories about angels visiting poor Jewish villages and other miraculous happenings. He told his listeners they did not have to know how to read Hebrew to pray because joyous worship was a form of prayer. He told them the world was a place of beauty, and joy could be found everywhere. God, he said, did not like to see long faces, but wanted

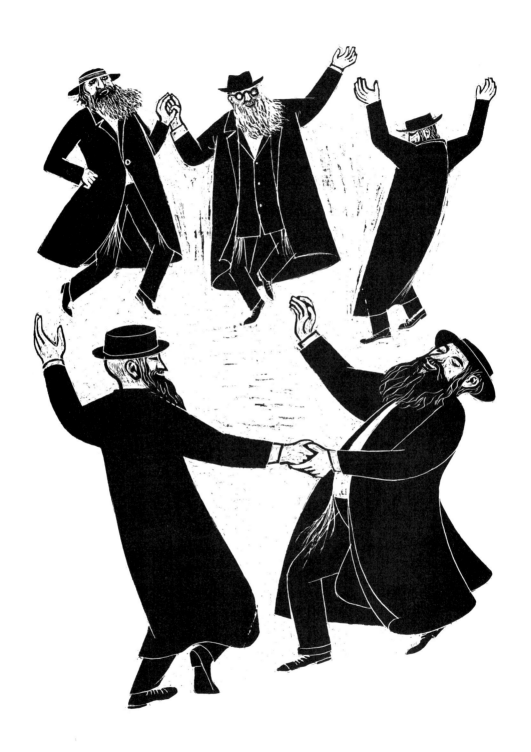

42

to see people happy. He told them to climb up to heaven on a ladder of joy.

All over Europe, millions of poor Jews found hope and became Hasidim. They sang and danced when they prayed. Today, this joyous worship is symbolized by the image of men dancing with upraised arms, their fringes, curls, and beards flying in the air.

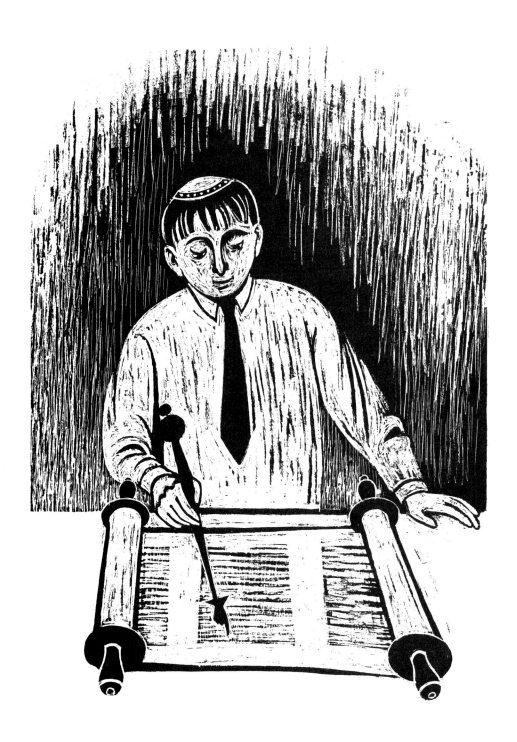

44

4. Symbols in Jewish Worship

Sepher Torah (Torah Scroll)

A *Sepher Torah* is a handwritten copy of the first five books of the Bible on long parchment rolls. A Torah often appears in art or design as a Jewish symbol. As such, it represents Jewish history. It stands for, among other things, the birth of the Jewish nation and the Ten Commandments that Moses received on Mount Sinai. It is also a symbol of the promise the Israelites made in the wilderness to worship only God and obey God's laws, and of the difficult times when Jews were forced to die for their beliefs, sometimes clinging to the Torah as they were slain.

A Torah evokes all these themes and more. It is sacred, God-given, and remains the Jews' most precious symbol. A scribe—a devout scholar and calligrapher—works for a long time under special conditions to prepare one. He writes on special parchment, with a special quill, in special ink. The final scroll is rolled on two wooden pins. When it is read in the synagogue, the scroll is placed on a table and unrolled. Jews call the Torah Scroll a "tree of life." They believe the study of the Torah leads

to good deeds, and that good deeds lead to a good life. In prayers, that thought is encapsulated in the phrase *It is a tree of life to those who cling to it, and all its paths are peace.*

Yad (Hand)

The Torah Scroll is written in an ancient Hebrew script. It lacks all punctuation and vowel marks. Reading a scroll is therefore an exacting process.

In ancient times, kings and prophets read the Torah aloud to the people. Today, rabbis and scholars do so on Sabbaths and holidays. They use a *yad,* which means "hand." This is a silver stick with a hand or finger at one end. The yad is a pointer or reading aid that helps the reader keep his or her place. It also protects the sacred document. Metal will not smudge or damage the handwritten text as a moving finger would.

Priestly Garments

Moses decreed that the ancient high priest wear garments "for splendor and for beauty." Thereafter, all high priests wore the same garments: a gold crown inscribed with the words "Holy to the Lord," and a blue robe with a string of pomegranate-shaped bells on the hem. In a superstitious world, bells were used to scare away the devil. The bells of the high priest, however, served a different purpose. They let people know he was on his way to the Temple. Over his robe was an embroidered apron, and on his chest a gold breastplate with twelve precious stones. Each stone symbolized one of the twelve tribes of Israel.

Since the destruction of the Temple, the high priest is gone from Jewish life. But the Jews who come from a European

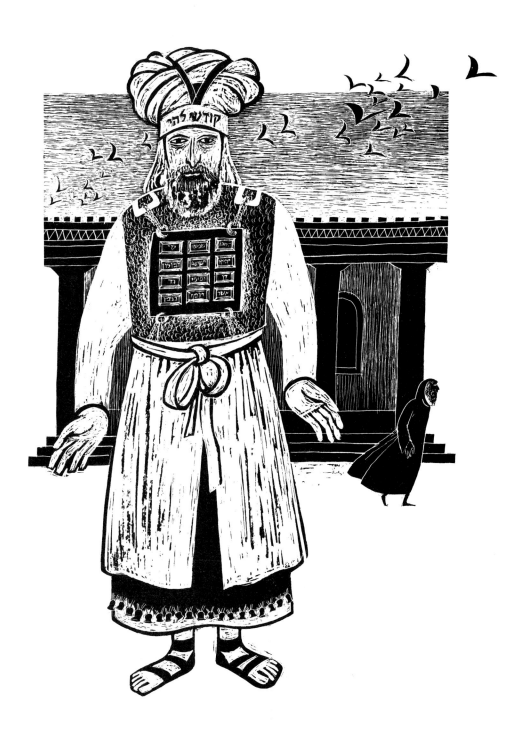

background preserve symbols of his garments. They are now used to protect the sacred Torah.

Torah Cover

A Torah Scroll is too precious to stand uncovered. European Jews dress it with a garment made "for splendor and for beauty," usually a velvet cover with gold ornamentation, a crown, a breastplate, and bells. Jews from Spain and Portugal, Africa, and the Middle East use a different symbol. They keep a Torah Scroll in a wooden box as the ancient Israelites did.

The Eternal Light and the Holy Ark

The portable box in which the Israelites carried the Law was the Holy Ark. At the time Moses directed them to build it, he also commanded them "to cause a lamp to burn continually" as a symbol of God's eternal presence. For that purpose, under the guidance of an artist named Bezalel, the people built a very large seven-branch candlestick of beaten gold. The light that burned continually they kindled in one of its seven cups. Today, the *Ner Tamid*, or Eternal Light, is a single electric lamp. As in ancient times, it burns perpetually and symbolizes the eternal presence of God. A cabinet, or ark, is built into the synagogue wall. It holds Torah scrolls and is often decorated with columns that suggest the design of the ancient Temple. The Eternal Light is usually located above the ark.

Priestly Blessing

With these words composed by Moses, the priests in the wilderness, and all priests thereafter, blessed the people: *May God*

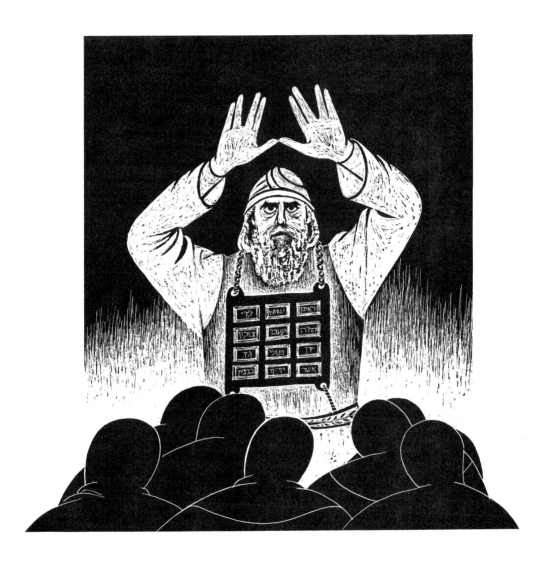

bless and protect you. May God look your way and be gracious to you. May God favor you and bring you peace. In Temple times, priests stood on an elevated platform to recite the blessing. As they spoke these words, they raised their arms high and parted their fingers so that each hand suggested the three points of the Hebrew letter *Shin,* for Shaddai. Some people stared at the space between the priest's shoulder and his fingers. They believed that there they could catch sight of the Shechinah, the aspect of God that dwells on earth. Today, in liberal synagogues, some rabbis recite the priestly blessing on the Sabbath and holidays. They do not, however, use the hand symbols. Only *Kohanim,* descendants of priests (which a rabbi may or may not be), are allowed to do so. In Orthodox synagogues, when a priestly descendant recites the blessing, he raises his arms and spreads his fingers. His hands are not seen, however. He covers himself with a tallit. It lifts up over his head, as if by itself, as he raises his arms and speaks the words. The hand symbols are considered too mysterious, too mystical, to be seen.

The Lion of Judah

A lion is a common symbol in synagogues. Two are often shown standing on hind legs on either side of two tablets of the Law as if they are guarding them. A single lion is the symbol of King David. The idea of a lion as David's symbol has its roots in the Bible. When Jacob was on his deathbed, he gathered his twelve sons together. (These sons and their wives founded the original twelve Israelite tribes.) Jacob told his sons what the future held for them. Of his son Judah, he said, "Judah is a

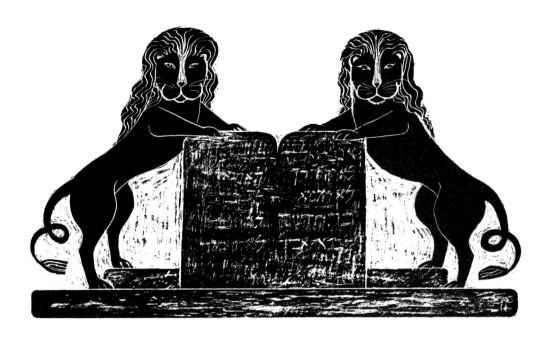

lion's whelp. He crouches, lies down like a lion, like the king of the beasts; who would dare rouse him? The scepter shall not depart from Judah, nor the ruler's staff from between his feet."

Jacob's prediction came true. King David was of the tribe of Judah. He founded a dynasty, a royal house. He, and his son King Solomon after him, came to be called "Lion of Judah." Their descendants ruled in the kingdom of Judah, which is today part of Israel.

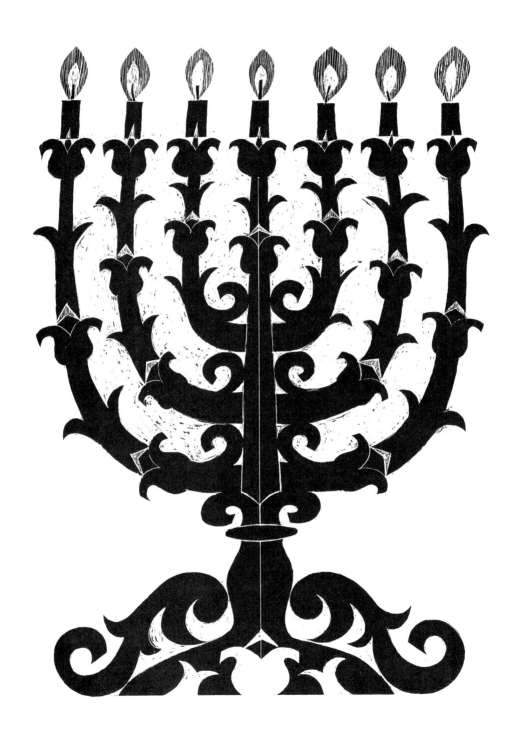

52

5. Symbols of the State of Israel

The Menorah

The seven-branch candlestick that Bezalel created in the wilderness was a *menorah*. It was later transferred to Solomon's Temple in Jerusalem.

When Titus, the Roman general, destroyed the Temple in 70 C.E., the menorah had been a Jewish symbol for a thousand years. Titus made it a symbol of his victory. He carried it back to Rome as a war trophy. To honor him, the Romans built him a monument, the Arch of Titus, which stands in Rome to this day. The arch depicts Titus' triumphant entry into Rome. It shows Simon, son of Giora, the captive Jewish general, and the menorah.

The rabbis of the time prohibited making a replica of the Temple menorah for religious use. Thereafter, menorahs began to appear as symbols, as designs in synagogue floors and on walls and tombstones. Later, seven-branch candlesticks were displayed in synagogues. Over the centuries, it acquired new

symbolic meanings. Some Jews saw the seven branches as representing the seven heavenly bodies, the seven heavens, or the seven days of Creation. The shape, a central shaft with three branches on either side, suggests a tree. The theme of a "tree of life" is common in Jewish thought. Thus, the menorah, like the Torah, is sometimes referred to as a "tree of life."

Another meaning has been added to the idea in modern times. A tree feeds and nourishes people. Its branches reach up to heaven, as if in supplication. It is miraculously renewed each season. Jews see the reestablishment of the State of Israel as an answer to their prayers over the centuries. Like a miracle, the State of Israel was reborn on its ancient soil. The Knesset (Israel's parliament) building now stands in Jerusalem, the city where King David once ruled. Opposite the entrance is a very large menorah. The menorah is the emblem of the State of Israel, and the menorah today symbolizes the renewal of Jewish sovereignty and the rebirth of the Jewish nation.

The Shield of David

Probably the best-known Jewish symbol is the Magen David, the Shield of David. The design—two triangles, one upside down—makes a six-pointed star, and is also called Star of David. Despite its popularity, this symbol is of relatively recent origin and has no real connection to King David. It endures because Abraham had a vision in which God said to him, "Fear not, I am a shield to you," and Shield is also a name of God.

The six-pointed star is an ancient design and was used by many ancient people. Its first use as a Jewish symbol was in

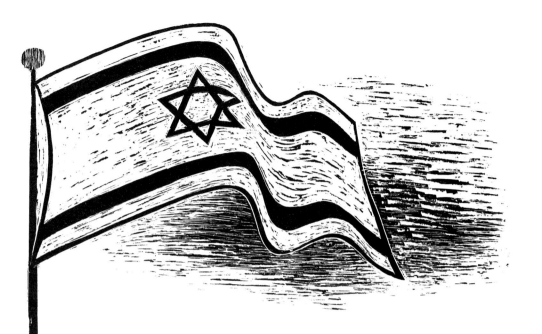

1354, in Prague, Czechoslovakia. Emperor Charles IV gave the Jews of Prague the right to have a flag. They chose the double triangle star as their symbol and displayed such a banner in the 1500s, when they went out to welcome the emperor to the city.

In the mid-1600s, an element was added. Prague was then under the rule of Emperor Ferdinand II of Austria. When Swedish forces attacked, the Jews helped to defend the city for the emperor. Ferdinand gave them in appreciation the right to adopt a coat of arms, an honor usually reserved for noble families. The Jews already had a banner with a star. They added a Swedish hat to the star for their coat of arms. In time, the Swedish hat disappeared from the Prague emblem, and the star alone remained.

Why the Prague Jews chose the double triangle is not known. One theory runs as follows: In the 300s B.C.E., tolerant Alex-

ander the Great conquered Jerusalem. He was succeeded by intolerant Greek rulers, and the Jews were forced to fight for their religious freedom. The design on the shields of the Jewish warriors was a six-pointed star. The Greek letter delta looks like a triangle, and according to the legend, one triangle stood for King David and the other for his descendant, the Messiah.

Many centuries later, the star entered Jewish history again. By the late 1800s, Jews had been separated from the land of Israel for almost two thousand years. Theodor Herzl, a Jewish writer in Vienna, called for the rebirth of the Jewish nation on its ancient soil. In 1898, he founded a movement called Zionism, after Zion, an ancient name of Jerusalem. Christians had a cross as a symbol, and Moslems a star and crescent. Herzl searched for a symbol for his movement and chose the star of David.

He could have chosen a symbol from his people's ancient past. The *shofar* (ram's horn) had been blown on special occasions from the time of Moses. A palm tree was the symbol of the tribe of Judah. A six-petaled rosette was a favored design in ancient times, but no one knew what it meant. Other symbols were associated with Jewish holidays. But Herzl wanted something new, something that stood for the reborn Jewish nation. According to his assistant, David Wolfson, their search was soon over. "We already had a flag, the blue and white of the tallit. . . . I ordered a blue and white flag, with the shield of David in the center."

Thereafter, the Shield, or Star, of David became the most common symbol of Jews. Hitler used it against them in World War II when he wanted to rid Europe of Jews. To separate them from the rest of the population, Nazis all over Europe made

Jews wear a Star of David on their clothing. This was the first step in Hitler's campaign of annihilation. It facilitated the second step, rounding up those so "branded" and putting them on trains destined for death camps.

Today, the blue-and-white-striped banner with the Shield of David in its center is the flag of the State of Israel.

6. Home Symbols

Mezuza

Many, if not most, of these symbols are likely to be found inside a Jewish home. A Bible, candlesticks, wine goblets, spice boxes, and menorahs are common. One symbol, however, is specific to the outside of the house. A *mezuza* fixed to the doorpost is the mark of a Jewish home. The mezuza has a long history.

Ancient Egyptians wrote lucky sentences over their doors to protect their homes. The Passover story in the Bible indicates that the Israelite slaves followed a similar practice. During the tenth plague, which killed all the Egyptian firstborn, the Israelites smeared their doorposts with lamb's blood. The mark was a sign to the angel of death to pass over that house.

As Moses taught the Israelites about God, he drove pagan ideas out of their minds. He created new signs to help them remember their vows to God. By the time they settled in Caanan, the Israelites were trained in the belief in one God. They wrote passages from Moses' teachings on their doorposts so they would see the sign as they came and went. Later, they kept the writing in a hollow in the doorpost. Today the writing

is contained in a small wooden or metal case attached to the doorpost.

Mezuza is Hebrew for "doorpost" and is also the name of the case. Like the phylacteries, a mezuza contains passages from Deuteronomy ending with the words: "And you shall write them upon the doorposts of your house, and upon your gates." On the back of the mezuza, visible through a tiny opening, is the Hebrew letter *shin*, for *Shaddai*, which means "guardian of the doors of Israel" and is also one of the names of God.

Though the mezuza was a religious object, many Jews saw it as an amulet, a source of protection. Sages discouraged this idea, saying an amulet has no power. The philosopher Maimonides went further. He said people who wrote the names of angels or holy names inside the mezuza were little more than fools. Nonetheless, many Jews continued the practice and even added three code words to the text. The code stood for the Hebrew phrase *Adonai Elohenu Adonai* ("The Lord our God is the Lord"). Some began to think of the code as a secret name of God.

Today, a mezuza on the right side of the door is a sign of a Jewish home. For many Jews, it is just that, a symbol. Some look at it as they come and go to remind themselves that no matter what concerns they face that day, God is the highest power. Others touch their fingertips to their lips and transfer a kiss to the mezuza, recalling the declaration of faith that it contains. Pious people, as they pass, place their hand over the mezuza and say, "May God keep my going out and my coming in now and forevermore."

Pushke (the Charity Box)

Pushke is the Yiddish word for "charity box." The small, simple metal box is a symbol of charity. It is found in Jewish homes, synagogues, Jewish stores, and community centers.

Hebrew does not have a word for "charity." The word used for giving is *tzedakah,* which means "justice." The idea of charity is assembled from biblical passages. Since everyone is created in God's image, as one passage states, everyone is entitled to food, clothing, and shelter. The Book of Leviticus says: *Love your neighbor as yourself.* Who is a neighbor? That understanding comes to us from various commands. The command to rest on the Sabbath applied to masters, servants, strangers, even beasts of burden. Commands to celebrate holidays stressed the inclusion of priests, strangers, orphans, and widows. A neighbor was each member of the tribe, of the community.

Biblical people were farmers, and laws of *tzedakah* (justice) are expressed in agricultural terms. One such law is designed to provide food for the poor: "When you reap the harvest of your land, you shall not reap to the corners of your field, neither shall you gather the gleaning of your harvest [crops the harvester missed]; you shall leave them for the poor, and for the stranger."

No minimum gift was required by law, but one did evolve over the ages. In Bible times, an *ephah* was a standard unit of measurement. An *omer,* one-tenth of an ephah, was a common amount. Abraham gave Melchizedek, a priest of God and king of Salem, a tenth of his possessions. Jacob, Abraham's grandson, promised God one-tenth of his wealth. Later, during the wandering of the Israelites, when manna appeared as food,

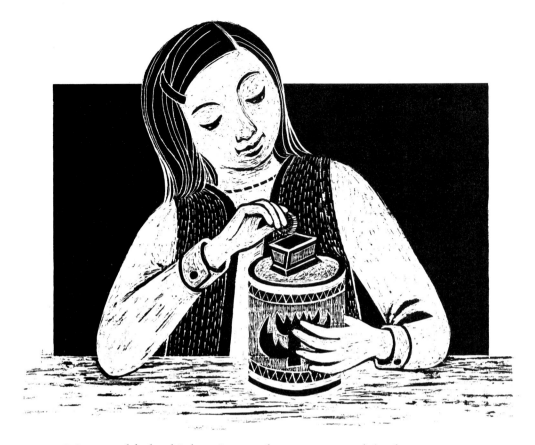

Moses told the high priest to keep an omerful of manna in a jar, as a remembrance. This amount, one-tenth, became a set sum. The English word *tithe* means "a tenth." The Israelites were taxed one-tenth of their income for the upkeep of the Temple.

In the first centuries B.C.E. and C.E., there was a charity room in the Temple, called the Chamber of the Secret Ones. Here no one spoke. People wordlessly left gifts for the poor. The men in charge of the room silently withdrew gifts and distributed them to those in need. The donor never knew who received his gift, and the receiver did not know who gave it.

Maimonides, writing about charity, graded those who shared their wealth. Heading his list were those who gave anonymously and those who gave so that others could become

self-supporting. He also suggested priorities. Poor and needy relations came first, then the poor and needy of the town, then those of the next town.

Today, Jews of means are expected to give one-tenth of their income to charity. Jews of limited means do so via a charity box. Each Jewish charity has a box—for widows and orphans, the handicapped, poor scholars, the aged, homeless refugees, and all such. Jews of limited means keep one box, sometimes two, at home. Members of the family put in coins every Friday night before blessing the Sabbath candles, or on special occasions.

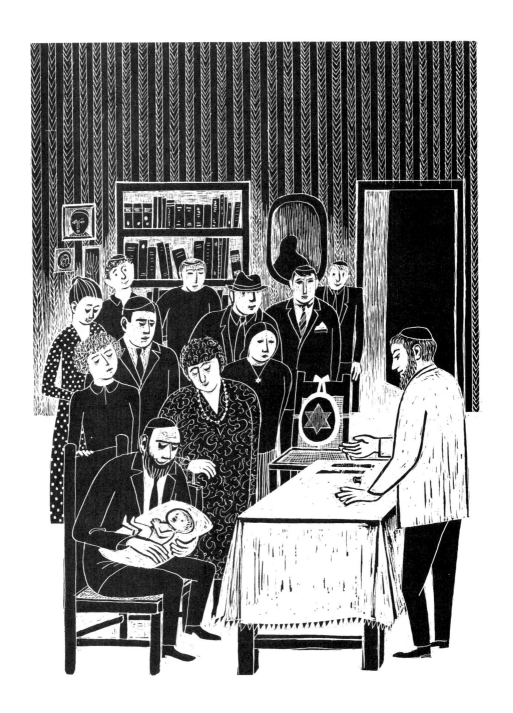

64

7. Symbolic Acts

Circumcision

The act that Abraham inaugurated some four thousand years ago is today a routine family celebration. Eight days after a boy is born, he is circumcised at a party called *Brit Milah*, or Covenant of Circumcision. The mark on the baby's flesh indicates that he, too, is a Jew, a member of God's first tribe. Also present, besides family and friends, is an important invisible guest—the Bible prophet Elijah.

The Bible tells about a conflict that raged between God's prophet, Elijah, and Jezebel, daughter of the king of Sidon, a city in Lebanon. Jezebel, a pagan princess, was married to Ahab, the Jewish king of Israel. She worshiped a god named Baal, whose symbol was a sacred pole. As a pagan, she was free to worship whatever gods she wished. The Jewish king, however, was not. He was sworn to the One God, yet he also worshiped the sacred pole. Jezebel was a brutal queen. She was ambitious to have the sacred pole worshiped throughout Israel. Her arch opponent in this was Elijah. He prophesied that Jezebel would be punished for her evil ways and die wretchedly. His prophecy came true. A new king had Jezebel thrown from the palace window, and her body was eaten by wild dogs.

Elijah was also a miracle worker. He brought a dead boy back to life and kept the food jars of a poor woman filled. He did not die in the usual way, but rose to heaven in a fiery chariot

and disappeared. His good deeds earned him a place in the teachings of Malachi, a later prophet. Malachi, speaking for God, told the people, "If you obey the laws of Moses, I will send you Elijah the prophet before the coming of the great and terrible day of the Lord."

What was the "great and terrible day"? This was interpreted to be a longed-for time, the coming of the Messiah. According to the prophecy, Elijah would bring the news that the Messiah was coming. Since any Jewish child might turn out to be the Messiah, Elijah is a symbolic guest at all circumcisions. He is represented by an elaborate chair known as the "Elijah Chair."

Redeeming the Firstborn

A second symbolic ceremony for baby boys comes from Moses' command to the Israelites to give their firstborn sons to the priesthood. This system was changed when the Tabernacle was built. Instead of individuals from all tribes, members of only one tribe, that of Levi, became helper priests. The Israelites honored the original command by a symbolic act. For five silver *shekels,* which they gave to the priests, they "bought back" the boy and freed him from priestly service.

In the 600s C.E., the *Pidyon Ha-Ben* (Redeeming the Firstborn) became a full-fledged ceremony and another occasion for celebration in the Jewish home. Thirty days after a baby boy is born, family and friends gather for the ceremony. Modern parents still "buy back" their first son with five silver coins in the local currency. A man who is a member of the tribe of Levi, the priestly tribe, officiates. The money goes to him, or to the synagogue. The boy himself, however, has a symbolic duty. When he is grown, he is expected to fast the day before Passover, in sympathy for the firstborn Egyptians who were slain.

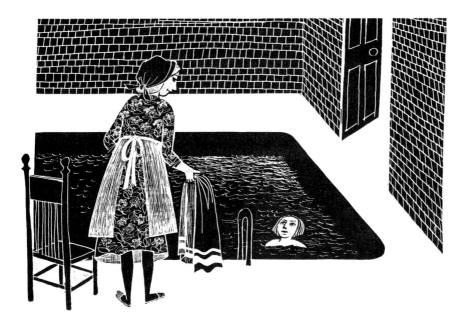

Spiritual Cleansing in a Mikvah

The ancient Israelites experienced God's presence in the wilderness. To prepare them for the occasion, Moses told them to purify themselves by washing. When Aaron, Moses' brother, was about to become the high priest, and his sons priests, they, too, were told to purify themselves by washing. The Prophet Ezekiel voiced the same idea when he said, "And I will sprinkle clean water on you and you shall be clean." Thus, washing in fresh water or rainwater, or immersion in the flowing waters of a stream or river, became standard practice to achieve spiritual purity.

Mikvah is Hebrew for a collection of water, or pool. The Temple area was holy. Before entering, Israelites cleansed themselves in one of the many mikvahs that were available for the purpose. The high priest and priests had their own mikvahs. Today, a mikvah is an indoor pool of fresh water. Men and women have separate pools. They first bathe to cleanse themselves, then step into the mikvah to make themselves spiritually clean.

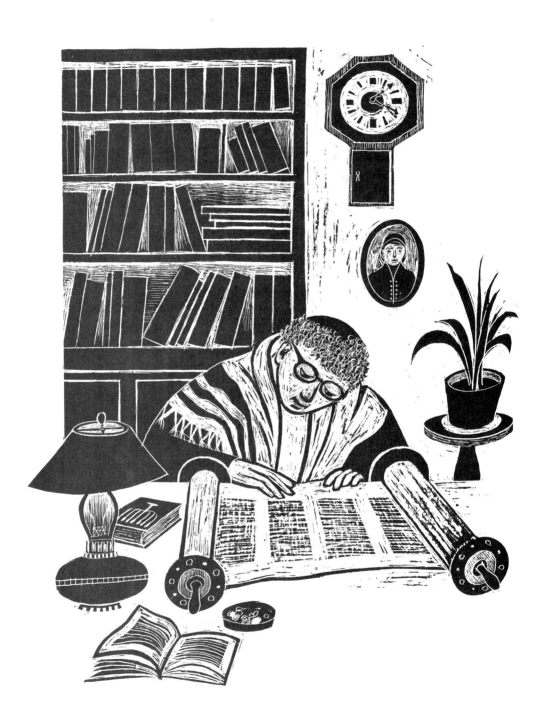

8. Number Symbols

Not all Jews share the same beliefs. Some don't believe in God but celebrate all Jewish holidays. Some don't believe in God and don't celebrate holidays but still call themselves Jews. Most Jews, however, do believe in God. Some go to a synagogue occasionally to pray. Some go once a week. Some pray daily, three times a day. Why three times? Because the rabbis, as they interpret the Bible, tell that Abraham prayed in the morning, Isaac in the afternoon, and Jacob at night. Some Jews are mystics who try to bring themselves closer to God by study and meditation. They look for hidden meanings and symbols in the Torah, in the twenty-two letters of the Hebrew alphabet, and in numbers. Some symbolic numbers have already been discussed. Here are others.

Three

Three is a favorable number because three names of God are often found together in prayer books: Helper, Savior, and Shield. It is also significant because three angels came to the tent of Abraham and Sarah, and because Jonah was inside the whale's belly for three days. Also, the patriarchs, the founding fathers of the Hebrew nation, were three—Abraham, Isaac, and Jacob.

Four

The number four applies to many of the basics. A tallit (a prayer shawl) has four fringes, one at each corner. The physical

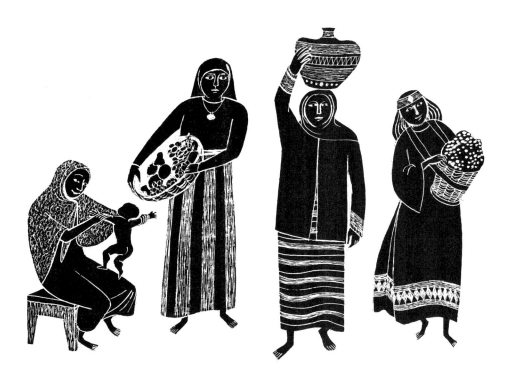

universe has four corners—east, west, north, and south—and is believed to be composed of four elements, earth, air, fire, and water. The four main archangels who form the universe of angels are Michael, Gabriel, Uriel, and Rafael. The matriarchs, the founding mothers, were four—Sarah, Rebecca, Leah, and Rachel.

Six

God is described in the Book of Exodus as possessing six qualities—compassion, graciousness, patience, kindness, faithfulness, and forgiveness. Mystics say the six qualities represent perfect order, and that when the Messiah comes, all people will possess them.

Seven

Mystics say there are seven heavens between humans and God. The number is also meaningful because of the poetic description of the seven voices of God in Psalm 29: *Powerful, full of majesty, capable of breaking the cedars, putting out flames, shaking the wilderness, causing hinds to calve, and stripping forests bare.* The Israelites found seven crops, which Jews view as seven blessings, when they arrived in the Promised Land: wheat, barley, figs, grapes, olives, pomegranates, and dates.

Eight

There is a saying: God made the world for people in seven days, therefore the numbers seven and below belong to humans. The number eight, being above seven, belongs to the realm of God.

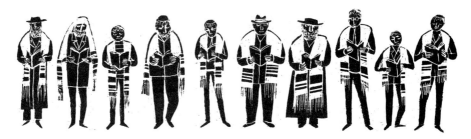

Ten

Ten is a symbolic number because of the Ten Commandments and also because of the story of Sodom. God planned to destroy the town of Sodom because its inhabitants were perverse and wicked. Abraham argued with God, saying there might be some righteous people among the inhabitants, and that it would be unjust to wipe out the righteous with the wicked. God agreed to spare the town if ten righteous people could be found. (They could not.) Ten has therefore come to stand for a quorum, a minimum number needed for certain ceremonial acts. The Hebrew word is *minyan*. Ten men are needed in an Orthodox synagogue before prayers can begin. In liberal synagogues, both men and women count toward a quorum. A minimum of ten families constitutes a Jewish community and is expected to establish a school and a house of prayer.

Twelve

There are twelve gates to heaven, one for each of the twelve tribes. The prayers of each tribe enter heaven through its own gate.

Eighteen

Hebrew numbers are formed from the letters of the alphabet. Thus, *alef,* or A, is 1, *Bet,* or B, is 2, and so on. The Hebrew

word *chai* means life. It is spelled *chet* (8) *yud* (10) and adds up to 18, the number symbol for life.

Thirty-six

There is a saying: The world is wicked, but in every generation there are thirty-six righteous souls, and for their sake, God lets the world exist. Thirty-six is written *lamed* (30) *vav* (6). These righteous are called *lamed vav-niks,* or 36-ers. They are usually humble people, so one must be kind to everyone, because anyone might be a *lamed vav-nik,* one of the thirty-six.

Forty

The number forty applies to a meaningful period of time. Moses kept the ancient Israelites wandering in the wilderness for forty years. David and Solomon each reigned for forty years. During the great flood, it rained for forty days and forty nights.

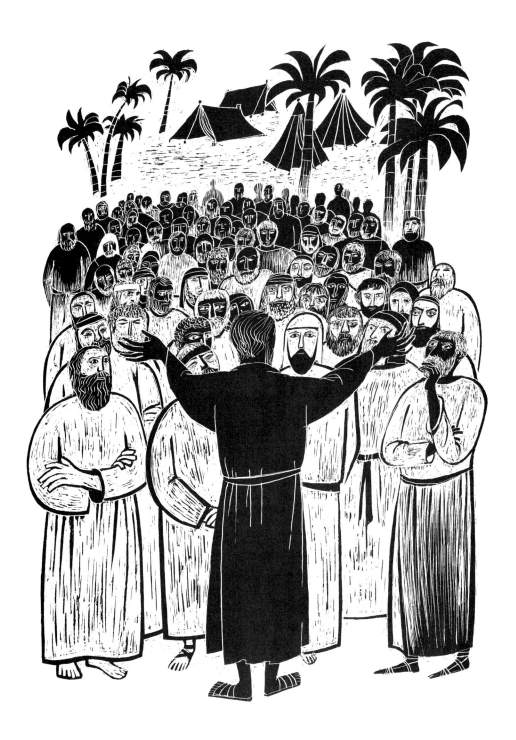

Fifty

According to a saying, there are fifty gates to wisdom. Everyone can gain wisdom through forty-nine. The fiftieth gate leads to spiritual wisdom, and only mystics can enter there.

Seventy

Seventy is symbolic of a total, a whole. Moses assembled seventy elders from among the tribes to help him govern the Israelites. Later, in Temple times, there was an academy of seventy elders called the *Sanhedrin*. Ancient Jews believed there were seventy basic nations in the world, and as many basic languages.

One hundred twenty

The significance of this number comes from the Noah story in the Bible. In it, God declared 120 years to be the span of a human life. Moses died at that age, which is seen as the ideal lifetime.

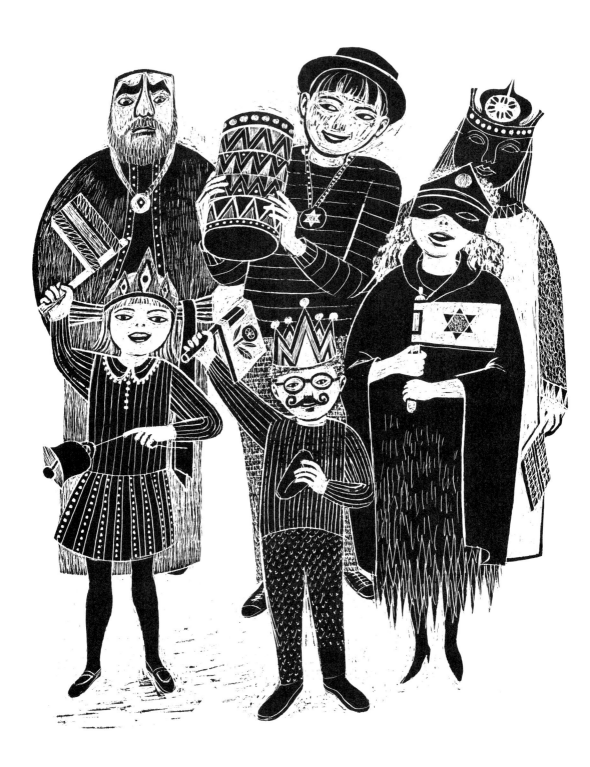

9. Holiday Symbols

Purim

Purim commemorates the rescue of the ancient Persian Jews from Haman, the king's chancellor, who sought to kill them. The Jews were saved by the King's Jewish wife, Queen Esther. The biblical book of Esther tells this story and is read aloud in the synagogue on the holiday. Each time Haman's name is mentioned, a *graggar,* or noisemaker, one of the holiday's symbols, is rattled to drown out Haman's evil name. *Hamantashen,* cookies shaped like Haman's triangular hat and filled with poppy seeds or fruit, are a second holiday symbol.

Passover

Moses led the ancient Israelite slaves to freedom and nationhood. Freedom allowed the Israelites to live as a people, worshiping God, celebrating their holidays on their own soil, and using God's laws as a guide to ethical behavior. The story is told in the Bible, in the Book of Exodus. The main symbol of the holiday is the celebration itself, at which these ancient

events are reenacted and retold during a *seder,* a festive meal. Another symbol is *matza,* a flat unleavened bread, which Jews eat for the eight days of the festival. It is a reminder of the bread the Israelites ate when they fled Egypt.

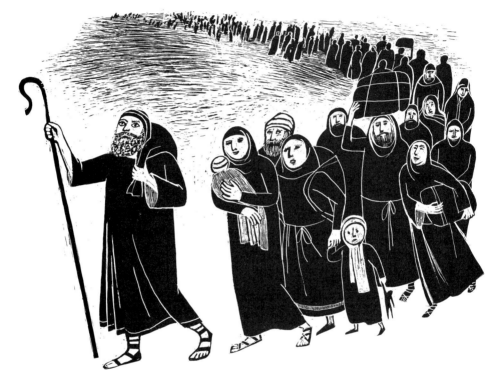

Shavuot (Weeks)

This ancient harvest festival is celebrated in Israel by outdoor dancing and singing and by displaying flowers and plants in the home. The holiday also has a religious component. Jewish scholars say Moses received the Ten Commandments seven weeks after the Israelites left Egypt. The religious component is called *Zeman Mattan Toratenu,* or the Festival of the Giving of the Torah. In Israel, first graders receive a copy of the Bible as a symbol of this event.

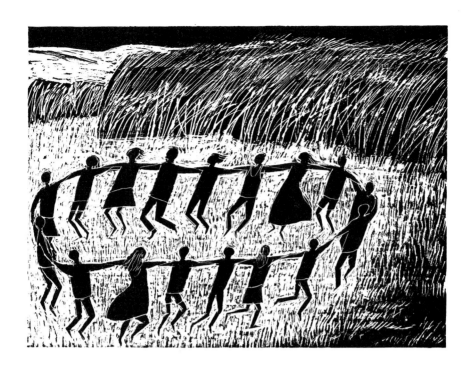

Rosh Hashanah (New Year) and Yom Kippur (Day of Atonement)

These are ten days of awe, so called because Jews are judged and judge themselves. They examine their behavior over the past year and seek forgiveness from God and from people they might have wronged. The shofar is blown in the synagogue on Rosh Hashanah morning to announce that the holiday is beginning. It closes at the end of Yom Kippur with the same sound.

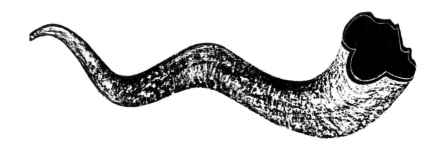

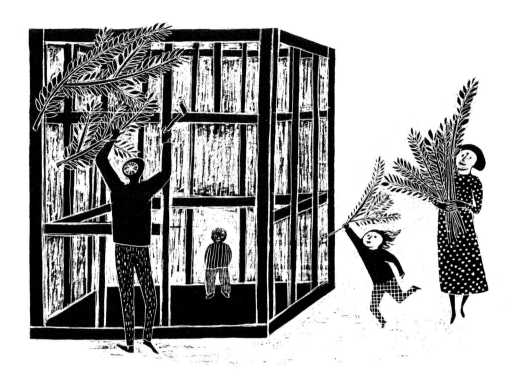

Sukkot (Booths)

When Nebuchadnezzar destroyed Jerusalem in 586 B.C.E., the Jews remaining there forgot their customs. Ezra, a Jewish scholar who returned from Babylon, taught them their past. He told them to celebrate *Sukkot* by dwelling in booths, temporary little shacks, because their slave ancestors lived in booths when they left Egypt. What kind of booths? Ezra told them: "Go forth unto the mount, and fetch olive branches, and branches of wild olive, and myrtle branches, and palm branches, and branches of thick trees." The booths and the plants from which they are made are symbols of the holiday.

Simchat Torah (Joy in the Torah)

This holiday falls on the ninth day of Sukkot. (Jews in Israel and Reform Jews celebrate the eighth day.) The Torah is read aloud in the synagogue throughout the year. On *Simchat Torah*, the reading is completed and at once begun again. To celebrate, people remove all Torah scrolls from the ark and carry them around the synagogue in a joyous procession. The Hasidim have a saying: The Torahs are dancing, the people only lend their feet.

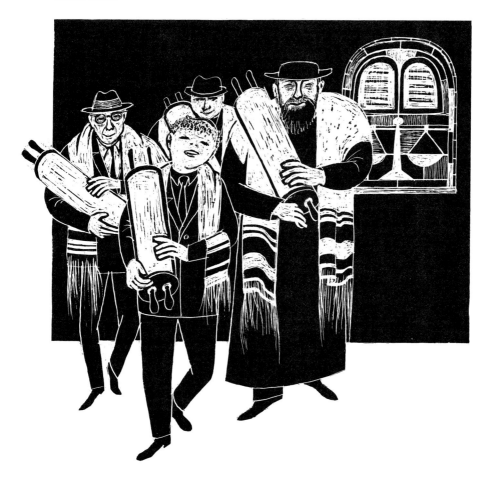

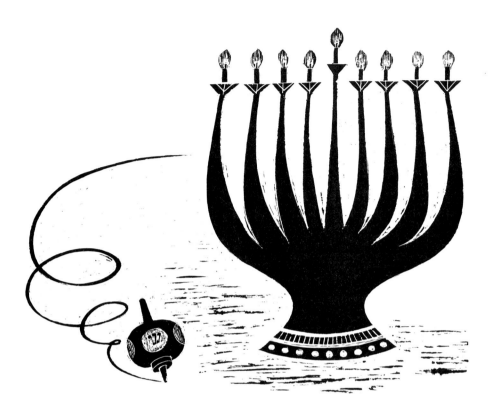

Hanukkah

The first war for religious freedom was fought some two thousand years ago by the Maccabees, a small band of Jewish warriors. Their victory was seen as a miracle because they drove a mighty army out of Jerusalem. The Jews took possession of their capital again and rededicated the Temple to God. *Hanukkah* means "to dedicate." As the Jews cleaned the Temple to purify it, they found a container of holy oil from earlier times. The oil was enough to burn for only one day, but, instead, it burned for eight, and this was seen as a second miracle. One symbol of this eight-day holiday is a *hanukkiah*, a candlestick

with eight cups, plus one, in which candles are burned each night. Another is a *dreidl*, a children's spinning toy, engraved with letters that stand for the Hebrew phrase *Nes Gadol Hayah Sham* (A Great Miracle Happened There). In Israel, instead of *Sham* (there), they say *Po* (here).

Symbols, Signs, and Reminders

These memory devices have served to link one generation of Jews to another for thousands of years. The Jews were an ancient people when Greece, then Rome, ruled the world. Those great empires are gone, but the Jews remain, true to the vows made by their ancestors in the desert wilderness, and loyal to their ancient past.

Notes

Author name alone indicates that the work is listed in the bibliography. Bible books are abbreviated. First numbered reference is to chapter, second to verse.

B.C.E.—Before the Common era. This is equal in time to B.C., or before Christ.

C.E.—Of the Common era. This is equal in time to A.D., or anno Domini, which is Latin for "in the year of our Lord."

Page

Introduction
1 *The rainbow as a sign:* Gen. 9:12–17.
2 *Amulets; seven; knots:* Kanof; also James Hastings, *Encyclopedia of Religion and Ethics*, Charles Scribners Sons.
2 *Seven heavenly bodies:* Sun, moon, Venus, Mercury, Mars, Jupiter, Saturn.
2 *Making an idol:* Isa. 44:9–18 (Isaiah was born in Jerusalem in the late 700s B.C.E.).
3 *Pact with Abraham:* Gen. 15:5.

28 *Angels in heavenly court:* Job 1–6.

28 *"Let us make mankind":* Gen. 1:26.

29 *Guardian angel quote:* EJ.

29 *Angels, general:* Hastings, see above: EJ; Trachtenberg; also Gustav Davidson, *Dictionary of Angels,* Macmillan Free Press; Theodore Ward, *Men and Angels,* Viking Press.

29 Demons as Punishment and Symbols of Evil

29 *Which trees to eat from:* Gen. 2:16–17.

29 *The Serpent:* Gen. 3:1.

30 *Satan:* Job, Chapter 1.

30 *"Two of every sort":* Gen. 6:19.

30 *Rashi comment on Gen. 6:19:* Trachtenberg.

30 *Demons:* Werblosky; EJ.

32 *Abracadabra: The Columbia Encyclopedia,* Columbia University Press; also Birnbaum.

33 *Three children's angels:* Raphael Patai, *A Book of Jewish Legends,* Avon.

33 *Amulets; spitting; number three:* Trachtenberg.

33 *Maimonides' beliefs:* Werblosky. (Rabbi Moses ben Maimon was born in Spain in 1135 and spent most of his life in Egypt as physician to the sultan's court. Christian scholars who studied his work called him Maimonides, which means "son of Maimon" in Greek.)

33 *Amulets:* Trachtenberg; Werblosky; EJ.

33 *Number thirteen:* Benjamin Appel, *Man and Magic,* Pantheon Books.

Symbolic Garments and Dress

35 Tallit

35 *One blue thread:* Maimonides; Kaplan.

35 *The command to wear fringes:* Num. 15:37–38.; Deut. 22:12.

35 *Why blue?* Birnbaum.

35 *The fringe as a sign:* Num. 15:39–40.

36 *Blessing for tallit:* Prayer book.

53 *Titus in battle:* Flavius Josephus, *The War of the Jews*, Penguin Books.

54 *Tree of Life:* Kanof; Werblosky.

54 THE SHIELD OF DAVID.

54 *God as a shield:* Gen. 15:1.

55 *First use of star in Prague banner:* Kanof.

56 *Greek letter delta legend:* Zlotowitz, see above; also Kerzer.

56 *Zion: City of David:* 2 Sam. 5:7.

56 *Palm tree as symbol:* Kanof.

56 *Rosette symbol: Biblical Archeology Review,* July/August 1988.

56 *Wolfson quote about flag:* Article by Robert Sugar in "Keeping Posted," see above.

Home Symbols

59 MEZUZA

60 *Mezuza as amulet, Ancient Egyptian door sign:* Kerzer.

59 *Smearing doorposts:* Exod. 12:22.

60 *"Sh'ma Israel":* Deut. 6:4–9; *"And you shall write them":* Deut. 6:9, 11:20.

60 *Maimonides on mezuza:* Article by Rabbi Manuel Gold in "Keeping Posted," see above issue; also Siegel; Donin.

61 PUSHKE (THE CHARITY BOX)

61 *In the image of God:* Gen. 1:27.

61 *"Love your neighbor":* Lev. 19:18.

61 *"Include the priest, the stranger, the fatherless, and the widow":* Deut. 16:11, 13.

61 *You shall have one law, the same for the stranger as for the home-born:* Lev. 24:22.

61 *"The tenth part shall be holy to the Lord":* Lev. 27:32.

61 *Food for the poor law:* Lev. 19:9–10; 23:22.

61 *Abraham gives a tenth:* Gen. 14:20.

61 *Jacob's vow:* Gen. 28:20.

62 *An omer of manna:* Exod. 16:33.

Holiday Symbols

77 PURIM

Celebrated on the fourteenth day (fifteenth in walled cities) of Hebrew month of Adar (February–March). When the Jews of Persia were rescued in 474 B.C.E., Queen Esther and Mordekhai declared, "Let a day be set aside to honor the time our people were saved."

77 PASSOVER

Celebrated on 15 Nisan (March–April) by biblical command: Exod. Chapter 13, line 3. Also Deut. 16:1.

78 SHAVUOT (WEEKS)

Celebrated seven weeks after the second day of Passover by biblical command: Lev. 23:15; also Deut. 16:9–10.

78 ROSH HASHANAH (NEW YEAR) and YOM KIPPUR (DAY OF ATONEMENT)

Celebrated 1 Tishri (September–October) by biblical command: "And the first day of the seventh month shall be to you a festival of horn blowing." Lev. 23:24–28. "On the tenth day of this seventh month is the day of atonement." Lev. 23:27.

80 SUKKOT (BOOTHS)

Celebrated 15 Tishri (September–October) by biblical command: Lev. 23:39; Deut. 16:13.

80 *"Go forth unto the mount"*: Neh. 8:15.

Bibliography

Reference Books

Abelson, J. *Jewish Mysticism: An Introduction to the Kaballah.* New York: Sepher–Hermon Press, 1981.

Bloch, Abraham. *The Biblical and Historical Background of Jewish Customs and Ceremonies.* New York: KTAV Publishing House, 1980.

Chill, Abraham. *The Minhagim: The Customs and Ceremonies of Judaism, Their Origins and Rationale.* New York: Sepher–Hermon Press, 1980.

Concise Jewish Encyclopedia, ed. Roth, Cecil. New York: A Meridian Book, New American Library, 1980.

Encyclopedia Judaica. Jerusalem: Keter, 1972.

Encyclopedia of Jewish Concepts, ed. Philip Birnbaum. New York: Sanhedrin Press, 1964, 1979.

The Encyclopedia of the Jewish Religion, eds. R. J. Zwi Werblosky and Geoffrey Wigoder. New York: Holt, Rinehart, and Winston, 1965.

Gersh, Harry. *When a Jew Celebrates.* New York: Behrman House, 1971.

Hertz, Dr. Joseph J. *The Daily Prayer Book.* New York: Bloch Publishing Company, 1948. Prayers and commentaries on meanings.

The Holy Scriptures. Philadelphia: Jewish Publication Society, 1917, 1955. The entire Bible in English.

Isaacson, Dr. Ben. *Dictionary of the Jewish Religion,* ed. David C. Gross. New York: Bantam Books, 1979.

Kanof, Abram. *Jewish Ceremonial Art and Religious Observance.* New York: Harry N. Abrams, Undated.

Kaplan, Aryeh. *The Bahir.* York Beach, Maine: Samuel Weiser, 1979.

Kaufmann, Yehezkel. *The Religion of Israel,* trans. Moshe Greenberg. New York: Schocken Paperback, 1972. University of Chicago Press, 1960.

Kertzer, Rabbi Morris N. *What Is a Jew?* Cleveland, New York: World Publishing Company, 1953.

Runes, Dagobert D. *Dictionary of Judaism.* New York: Philosophical Library, 1959.

Siegel, Richard, et al. *The First Jewish Catalog.* Philadelphia: The Jewish Publication Society of America. 1973.

The Torah, A Modern Commentary. Commentaries and essays by W. Gunther Plaut and others. New York: The Union of American Hebrew Congregations, 1981. The first five books of the Bible in Hebrew and English.

Trachtenberg, Joshua. *Jewish Magic and Superstition: A Study in Folk Religion.* New York: Behrman's Jewish Book House, 1939.

Books for Young Readers

Appel, Benjamin. *Man and Magic.* New York: Pantheon, 1966. A readable account of ancient beliefs and practices around the world.

Burstein, Chaya M. *The Jewish Kids Catalog.* New York: Jewish Publication Society, 1983.

Cashman, Greer Fay. *Jewish Days and Holidays,* illustrated by Alona Frankel. Jerusalem: Massada Press, 1976; New York: SBS Publishing, 1979. Jewish symbols and meanings for all ages.

Chaikin, Miriam. *Ask Another Question: The Story and Meaning of Passover.* New York: Clarion Books, 1985.

——. *Light Another Candle: The Story and Meaning of Hanukkah*. New York: Clarion Books, 1981.

——. *Make Noise, Make Merry: The Story and Meaning of Purim*. New York: Clarion Books, 1983.

——. *Shake a Palm Branch: The Story and Meaning of Sukkot*. New York: Clarion Books, 1984.

——. *Sound the Shofar: The Story and Meaning of Rosh Hashanah and Yom Kippur*. New York: Clarion Books, 1986.

Cohen, Mortimer J. *Pathways through the Bible*, illustrated by Arthur Szyk. Philadelphia: Jewish Publication Society, 1946. An interesting, simplified telling of the Bible, with relevant commentaries.

Cone, Molly. *Stories of Jewish Symbols*, illustrated by Siegmund Forst. New York: Bloch Publishing Company, 1963. Legends and stories introduce Jewish symbols.

Drucker, Malka. *Celebrating Life: Jewish Rites of Passage*. New York: Holiday House, 1984. Text and photos about events in Jewish life and their symbols.

Kitman, Carol, and Ann Hurwitz. *One Mezuzah: A Jewish Counting Book*. Chappaqua, New York: Rossel Books, 1984. Attractive full-page black-and-white photos and few words.

Levin, Meyer, and Toby K. Kurzband. *The Story of the Synagogue*. New York: Behrman House, 1957. About symbols in Jewish worship.

Rubin, Alvan D. *A Picture Dictionary of Jewish Life*, illustrated by Lili Cassel. New York: Behrman House, 1956.

Syme, Deborah Shayne. *The Jewish Home Detectives*, illustrated by Marlene Lobell Ruthen. New York: Union of American Hebrew Congregations, 1981. A search for Jewish symbols around the home.

Index